Painting Figures in Light

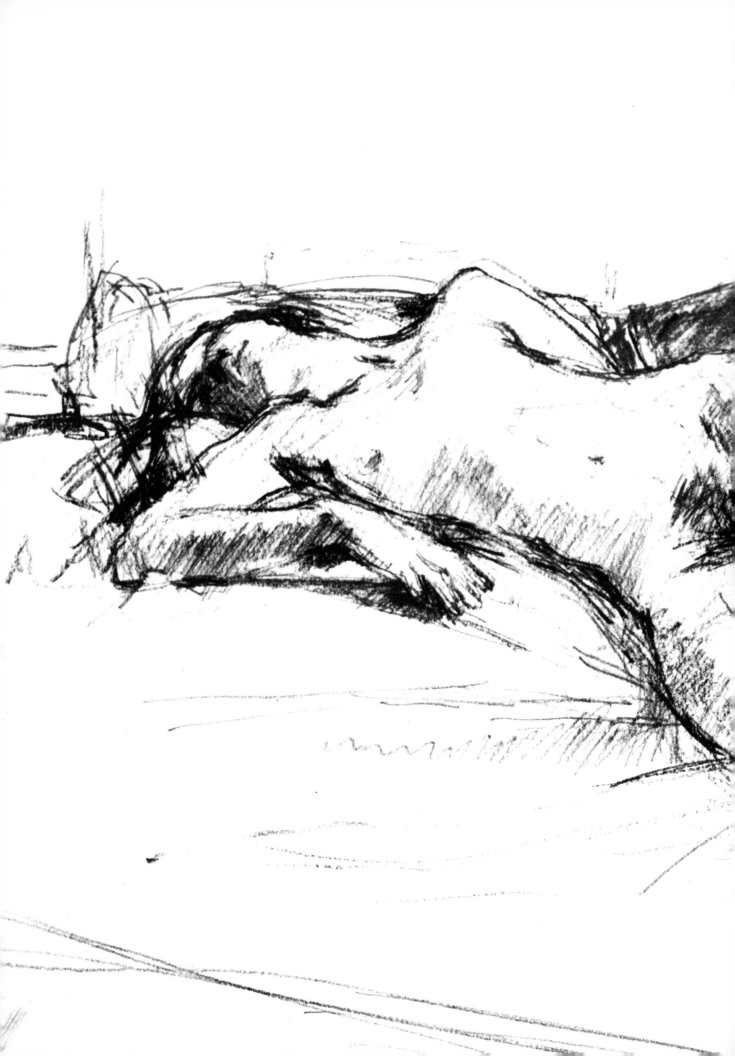

Painting Figures in Light

BY JANE CORSELLIS

WATSON-GUPTILL PUBLICATIONS/NEW YORK

For David, Nicholas, and James.

First published 1982 in New York by Watson-Guptill Publications,
a division of Billboard Publications, Inc.,
1515 Broadway, New York, N.Y. 10036

Library of Congress Cataloging in Publication Data
Corsellis, Jane.
 Painting figures in light.
 Includes index.
 1. Human figure in art. 2. Light in art. 3. Painting—
Technique. 4. Artists' preparatory studies. I. Title.
ND1290.C67 1982 751.45'42 82–8444

ISBN 0-8230-3631-6

Manufactured in Japan

First Printing, 1982
1 2 3 4 5 6 7 8 9/86 85 84 83 82

Many thanks to Bernard Dunstan, to
the editors David Lewis and Bonnie Silverstein,
to Bob Fillie for the design, and to Rado Klase
for the photographs.

Contents

Introduction

To write about one's own work as a painter is not quite as easy as it sounds. When it is merely a matter of the "cookery" (as one might call it) of the business—such as what colors to use or how to prime a canvas—all is plain sailing. But when it comes to the actual development of a picture, from the first idea to the final touches, describing the internal thinking process is another matter, increasingly difficult to put into words as the painting develops. So much of what an artist does is the product of intuition and experience and comes from largely unconscious, or at least semi-conscious, levels that cannot easily be analyzed. A painter's own private methods and processes, developed over the years, have little to do with verbalized consciousness; they dwell, so to speak, in the fingertips. Therefore, much of the business of painting must consist in pushing the paint about, in the hope of getting the image on the canvas a little nearer to a mental image—specific or vague, according to the individual—and letting the changes that occur suggest new directions without losing the all-important first idea, the impulse that started off the whole thing, which can so easily be overlaid.

This "pushing the paint about" is a mysterious process—"fudging it out," as old William Hunt called it. How is it possible to put into words the continual play that goes on between the demands of the subject, with all its emotional and associative implications, and those of the picture plane, the formal qualities, the pattern? I am talking of figurative painting here; I'm afraid that abstract painters, whatever other joys they may experience, do not know this one.

In talking of the process of painting, it is also possible to oversimplify it, making it appear that painting is just a craft like any other, where you start at Stage 1 and finish at Stage 10 with something to hang on the wall. Perhaps the craft of painting was once like that, but all I know is that it isn't any longer.

One thing that makes *Painting Figures in Light* so valuable is that Jane Corsellis has resisted all temptations to simplify. We learn from this book more important things than what was done in Stage 1 or Stage 2; we learn what it feels like to be a painter, how the *seduction* of the original idea (in Bonnard's words) must be retained, that primary, strong reaction to the subject matter that must come from deep, unconscious levels. This need to do a certain picture must take hold of the artist and dominate the development of the painting. Yet it must be capable of being modified by the ever-present demands of the medium, for otherwise the idea can lapse into mere illustration. Jane Corsellis is absolutely honest about the way she works. She never tries to make it seem easier or more cut-and-dried than it was. But she doesn't fall into the opposite trap either, of making the whole thing into a private, obscure mystery.

There are many other reasons for me to recommend her book, too. Jane Corsellis is dealing here with an absolutely central subject—the human figure in an interior setting, seen under certain very specific effects of light. I call this "central" because this subject is one of the continual preoccupations of European art, and so much part of all of our lives that it must present new facets to everyone who attempts it. It seems to me that Jane Corsellis' most characteristic pictures always have a strong sense of subject, often a mood rather than a story, seen in essentially painterly terms. Her subjects are very important to her and, although they cannot be separated from their translation into paint, they nonetheless form the essential impetus of the picture.

Throughout the book, Jane Corsellis stresses the fundamental importance of drawing. Another preoccupation, by no means opposed to this, is light. This medium that the figure stands in, reflects, or is bathed by, is an aspect of the subject that has been neglected lately, perhaps due to a slightly puritanical reaction against impressionism, or rather against that popularized version of it which relied rather heavily on artificial "effects"—portraits with spotlit backlighting, and so on. For a long time it has been respectable for students to paint everything in a flat light, with no wicked highlights or reflections, and indeed the whole tendency of post-impressionism has pointed in this direction. But if we forget the pundits and the schoolmasters, and go on painting what we like, using any method we like (and this roughly defines the position of the lucky figurative painter today), there will always be those who, like Jane Corsellis, are in love with the way light falls on flesh, on objects, and on the interior scene. She tells us here, unpretentiously and honestly, how she distills her own particular magic from these aspects of the perennial subject-matter—the person in the room—that has occupied European artists for the last four centuries, and will, for all we know, continue to keep them busy for a few centuries more.

Bernard Dunstan

Part One
Drawings for Paintings

I think that I am very fortunate in that I love painting and drawing the things around me. I feel a constant delight in looking at landscapes, objects, people, and especially interiors. I find that I am rarely at a loss for ideas for a painting. I can never understand when people say they cannot think of what to paint. For me, it is more a question of what not to. I do not have a real sympathy for pure abstract painting because I feel that in my traditional (representational or figurative—call it what you will) way of painting I can use a far greater abstract design in the composition of my paintings.

I usually keep a small, pocket-sized sketchbook with me at all times, a habit picked up when I was at art school. I find it invaluable for making very quick notes of some visual incident. I prefer the loose-leaved type of sketchbook not only because I can tear the page out for future reference, but also because I feel inhibited when drawing in a beautifully bound book. I feel it must be an especially good drawing to warrant such extravagance. This is not as ridiculous a statement as it sounds because I believe you must be totally free and at ease with your materials. I always use the best paints and paper I can afford because I can rely on them.

I sometimes spend weeks worrying about an idea for a painting, working out drawings in pencil, charcoal, and watercolor, just scribbles and diagrams that are not intended for showing, purely as information for myself. I'm ashamed to say they usually end up on the studio floor, although I do try to file them away for future reference. Once I have the basic plan underway, I transfer it to canvas as soon as possible. It may remain in this embryo state for a while, but I know I can work on it again whenever I wish. I may have anything up to ten canvases at a time in this state, working on one for a while and then moving on to another. In order to do this I must have a number of canvases stretched and ready for use.

Working with Models

A year or two ago, I had been finding the cost of employing a professional model too great. Also, the presence of just one other person was becoming increasingly disturbing, probably because it was getting difficult to detach myself from the sitter. I was constantly wondering whether the model was hot or cold, tired, or uncomfortable, or bored. Since my studio was too small to share with a friend in order to split the expenses, the best answer seemed to be the impersonal atmosphere of the local life class.

At first I found the crowded life class relaxing. The model was posed by the teacher and I could work from different angles, moving about quite uninhibitedly. She would rest when the time came and was totally unself-conscious in her work. But I had forgotten the distracting interruptions: people arriving late or leaving early who totally destroyed the concentration of those still working. So after a while I decided to return to my studio and work on my own again.

By chance a friend on my street was not working during the mornings and agreed to sit for me. Sitting, she told me, would be a marvelous change from her active work the rest of the day and, yes, she promised to tell me the second she was cold. So it was in this completely restful atmosphere that we started work.

She was a natural model, taking poses that were immediately graceful and interesting. We would start a session with quick poses from two minutes leading to twenty minutes by the end. She would stand, sit, and lie down, all completely naturally. I asked her to try and forget I was there and just get dressed an undressed again as if she was in her own bedroom. Whenever I found a movement particularly beautiful, I would say, "Stay like that for as long as you can" and then I would start drawing as quickly and as accurately as I could. These quick poses were invaluable because they gave me no time to consider each line as a separate entity, but taught me to see the figure as a whole and to constantly relate the figure to the surroundings.

The following sketches are examples of the kind of drawings I do that may later become the basis for a painting. They are done in various mediums and most of them are based on quick poses, some no more than two minutes. Several were drawn in my studio, while others were done in the life class I described. When you examine them, you will understand how important I feel it is to include background shapes, drawing them at one with the figure. Also observe that I pay careful attention to the shapes that the shadows make as they fall across the figure and other objects in the scene. While individual lines of anatomy are interesting in themselves, I never let them interfere with seeing the figure and background as a whole—if they break up the lines of the drawing, I leave them out.

I regard charcoal as the draftsman's equivalent of the brush. I find this medium very sympathetic for quick figure drawings. You can draw fine lines with one movement and block in a tonal mass just as quickly with another. If the drawing becomes too black, I can lift out areas using either a piece of soft bread or a kneaded eraser, and white chalk can be used to draw into the dark sections. The drawing will progress layer upon layer and in spite of this can still retain a freshness.

I often pose a model against a window. Drawing a dark, shadowed figure against a bright light forces you to concentrate hard to see the subtle changes of color and tone on the skin. I also like the way the hard lines and angles of the windows and doors counteract the curves and lines of the body.

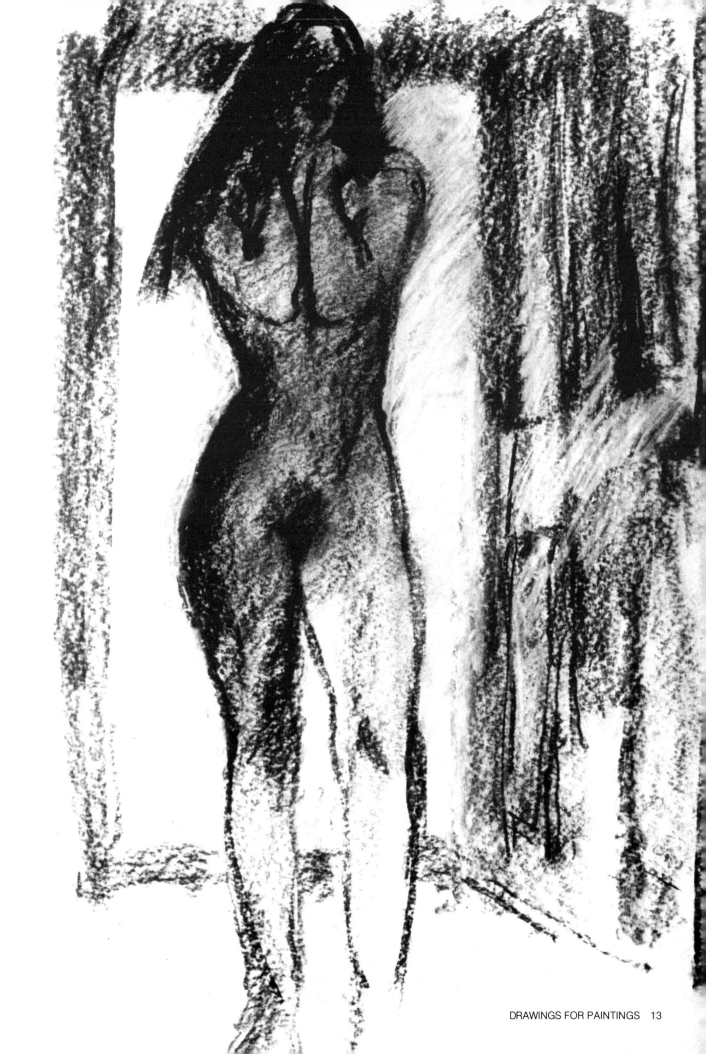

I try to draw the model without being con-
scious of the specific medium I am using.
Thus I handle a pencil with much the
same fluidity as I would a brush. Working
in pencil, I define and redefine the shape
of the figure with sharp lines. Then I add
soft, oblique strokes to give form and tone
to the figure.

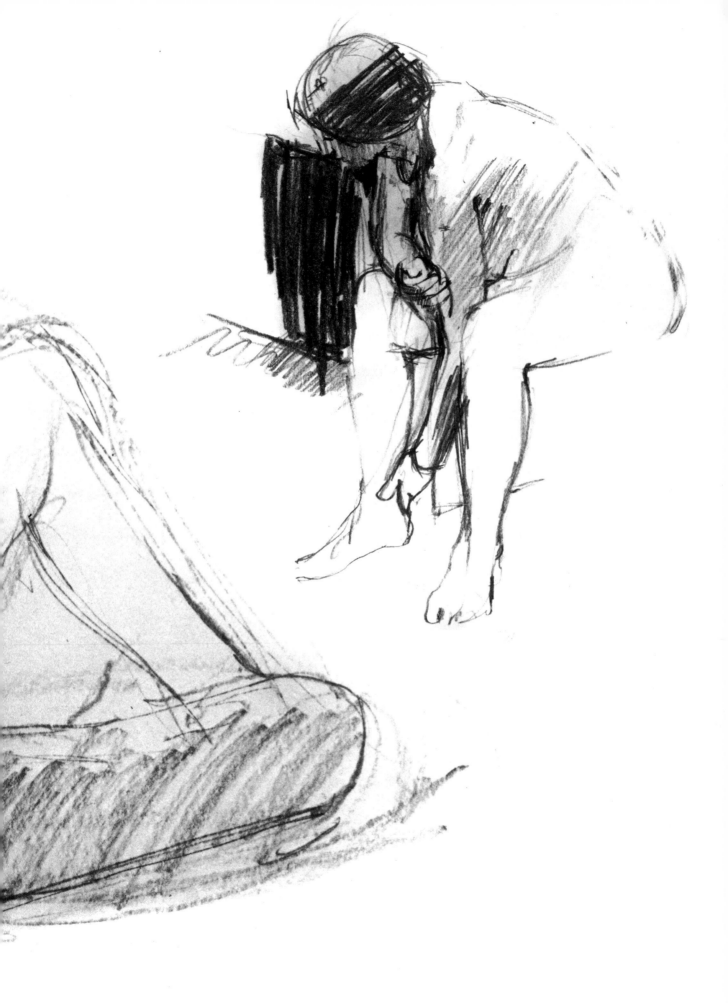

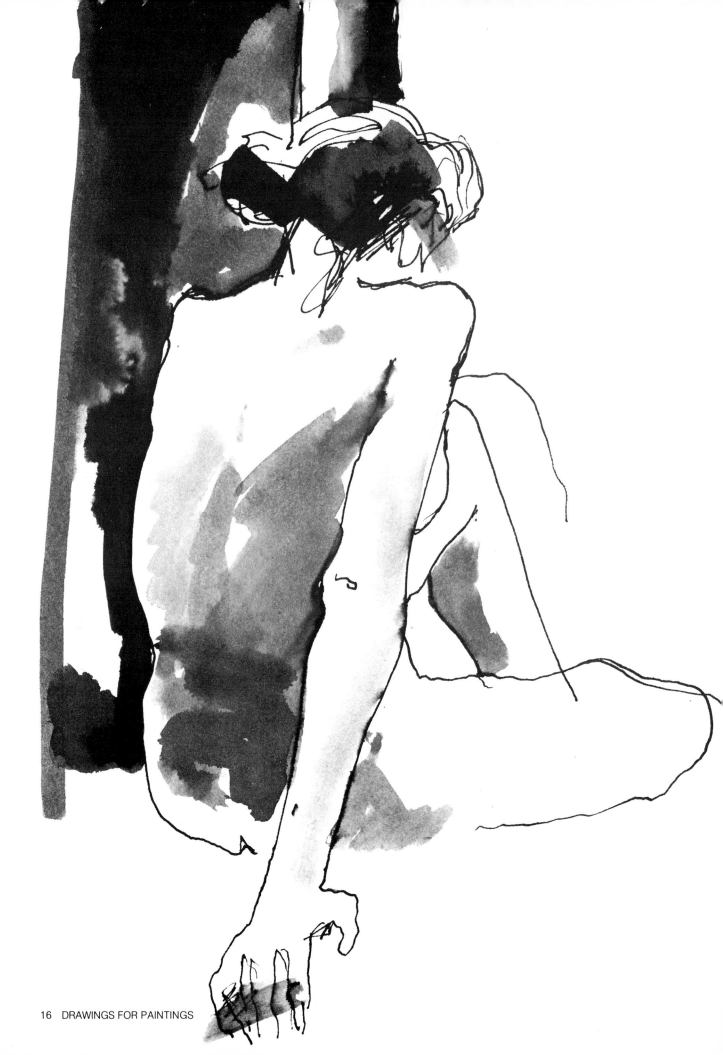

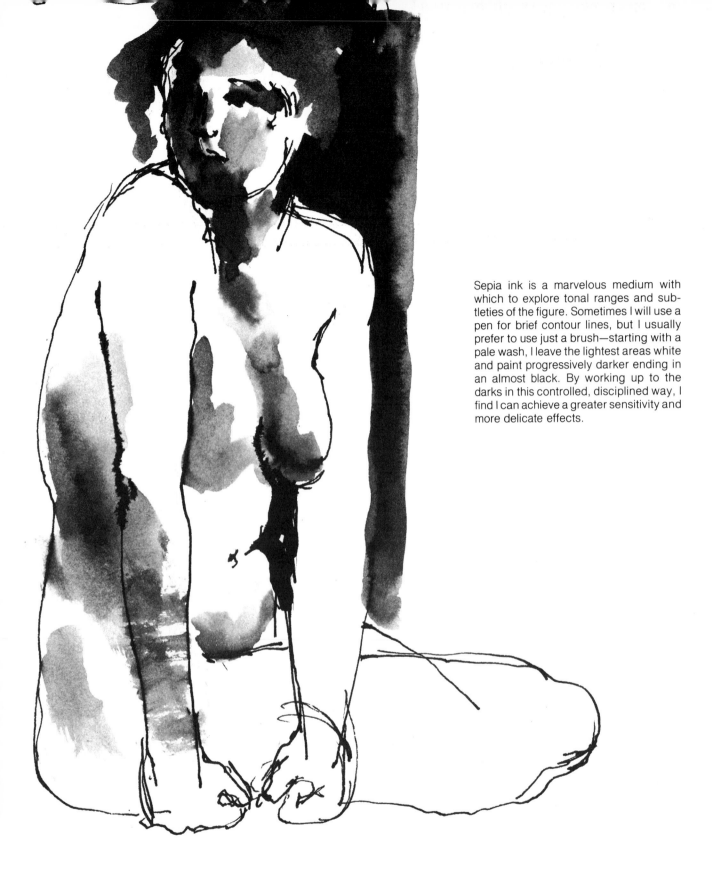

Sepia ink is a marvelous medium with which to explore tonal ranges and subtleties of the figure. Sometimes I will use a pen for brief contour lines, but I usually prefer to use just a brush—starting with a pale wash, I leave the lightest areas white and paint progressively darker ending in an almost black. By working up to the darks in this controlled, disciplined way, I find I can achieve a greater sensitivity and more delicate effects.

I like to work directly on paper with water-color, without preliminary drawings in pencil, using a wet technique of washes. I can then pinpoint the accents later with an almost drybrush method. I love water-color for all its ''accidents,'' the way one color bleeds into another, and the way the pigments separate from the water, making exciting textures.

When I am painting from a model I like to let her choose her own poses for quick studies. These usually last from five to ten minutes at a time and, since I never know how long she will be able to hold the pose, I have to work as quickly and freshly as possible, without worrying if these watercolors will work as drawings, because I am after the spontaneity that comes with acute observation. It is only later, after the model has gone, that I can sit back and evaluate my work.

As I work, I make many quick decisions. For example, looking at the figure I may think, ''It's cool on one side. How cool? Green cool,'' and lay in that color. Then I may see that the area next to it is ''blue cool,'' and lay in that color. Next I may find that the legs are a warm tone, though tinged with blue, and wash them in accordingly. In this way, I relate one patch of color to another like pieces of a jigsaw puzzle. The colors I use often describe the feeling of the scene rather than the actual reality because it is the tonal value and mood that is the essential information I need to retain. Any color that has the right value will work, despite its un-reality.

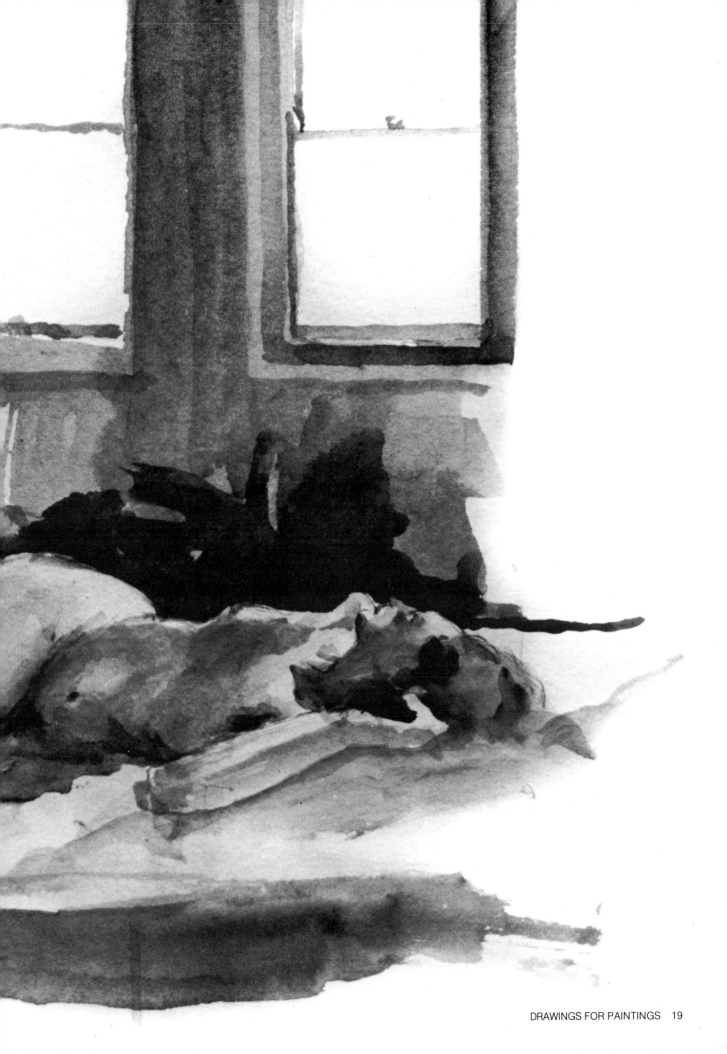

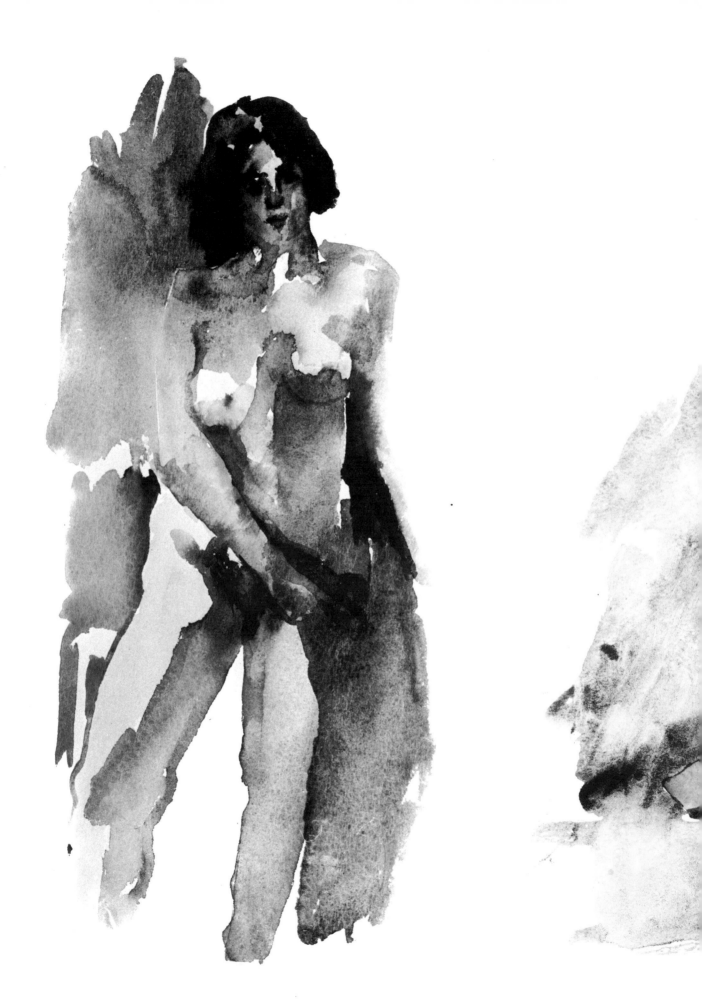

It is difficult to draw the figure in a foreshortened position—the proportions look glaringly awkward if they are not right. So I spend much time calculating the correct line and angle to ensure a credible result. The torso of the seated girl provides a good example of watercolor used with generosity to give a firm tone. Although I painted the face and hands in some detail, the drawing would be no less strong without these defined features. If I had a moist sponge with me at the time, I would have lifted out some of the color in her face to make it a little softer.

I always look for unexpected shapes when I draw, such as the triangles of light or dark tone between the arm, breast, or knee. These negative shapes add interest to a drawing.

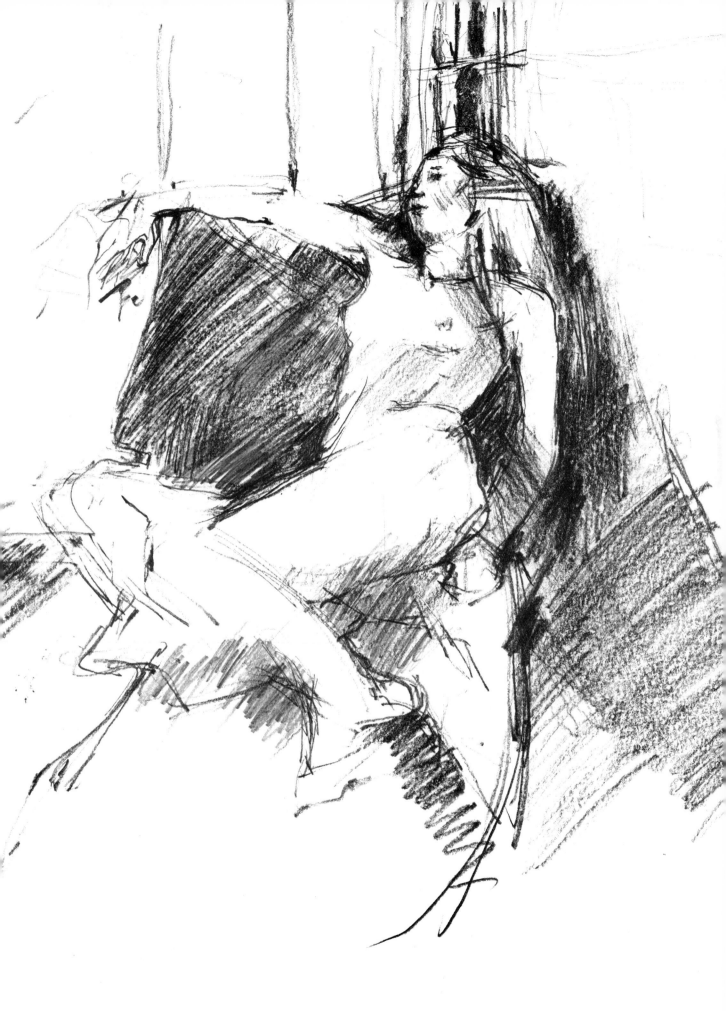

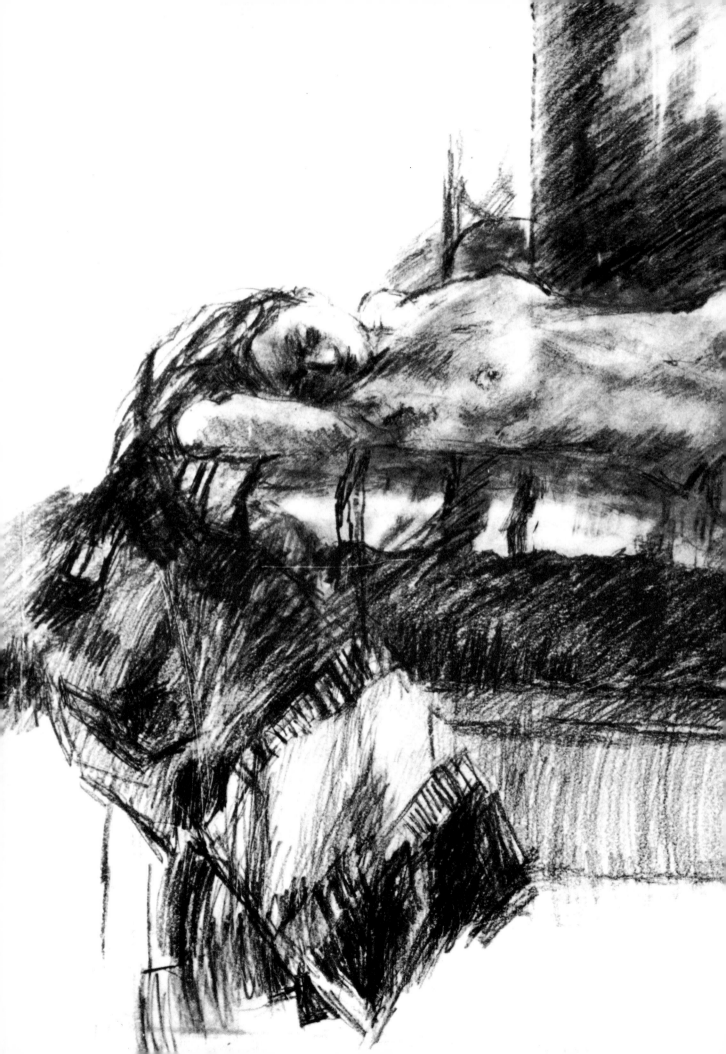

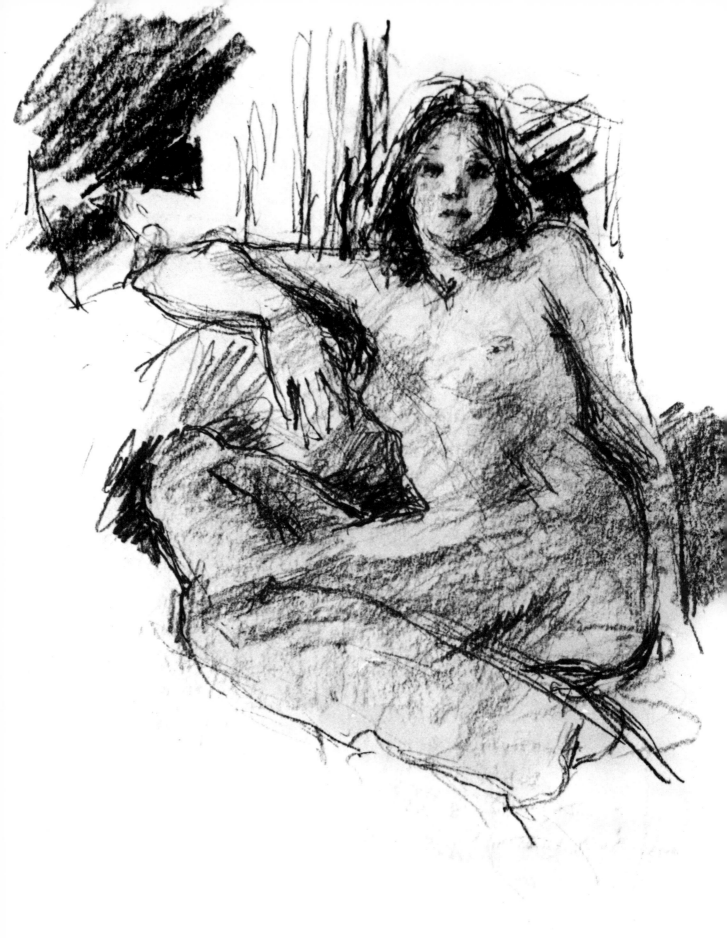

I am very much aware of the pattern a figure makes against a background and constantly relate the two areas as I draw so that they form a network of patterns.

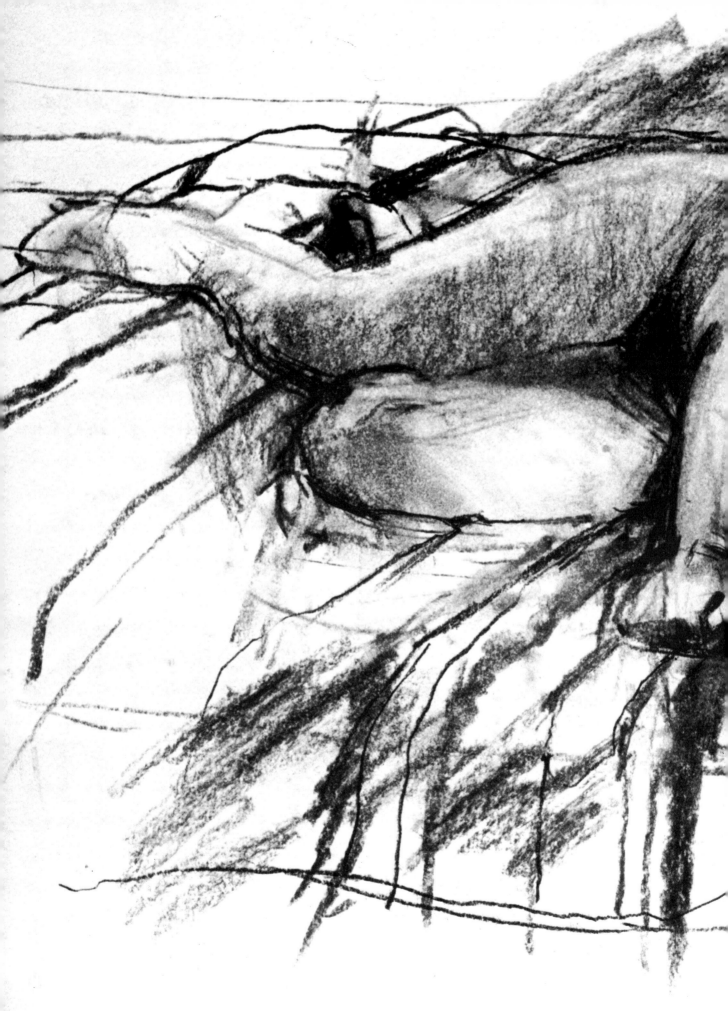

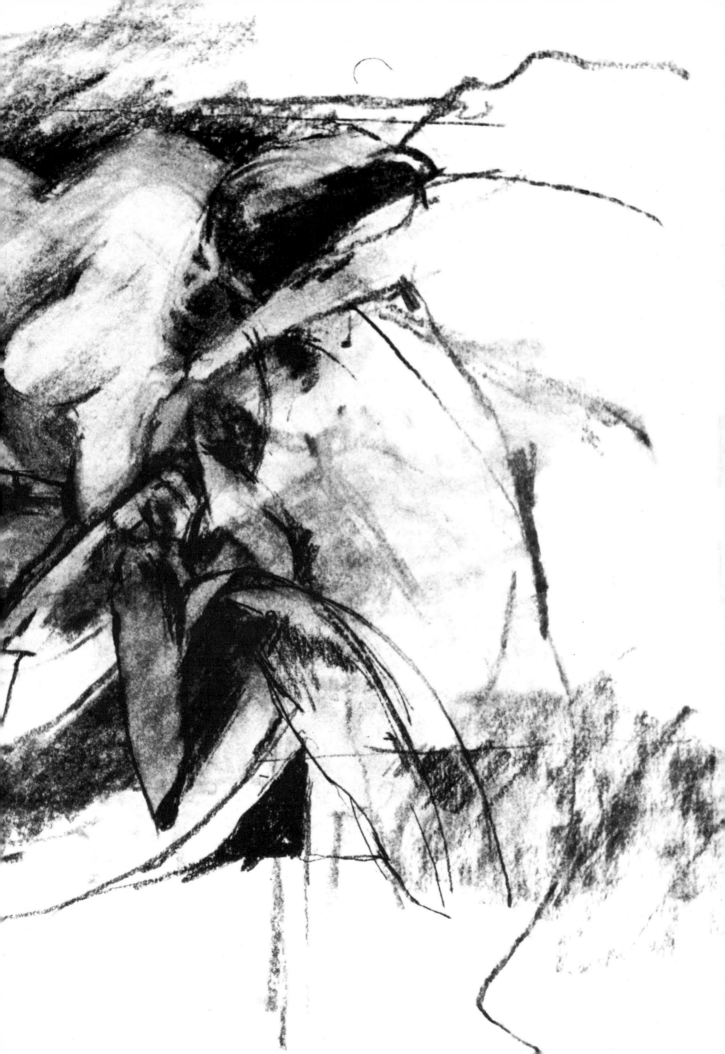

I like drawing moving figures in awkward, hard-to-hold poses like this. Sometimes a dark negative shape, like this background, silhouettes a positive shape, such as the model's form.

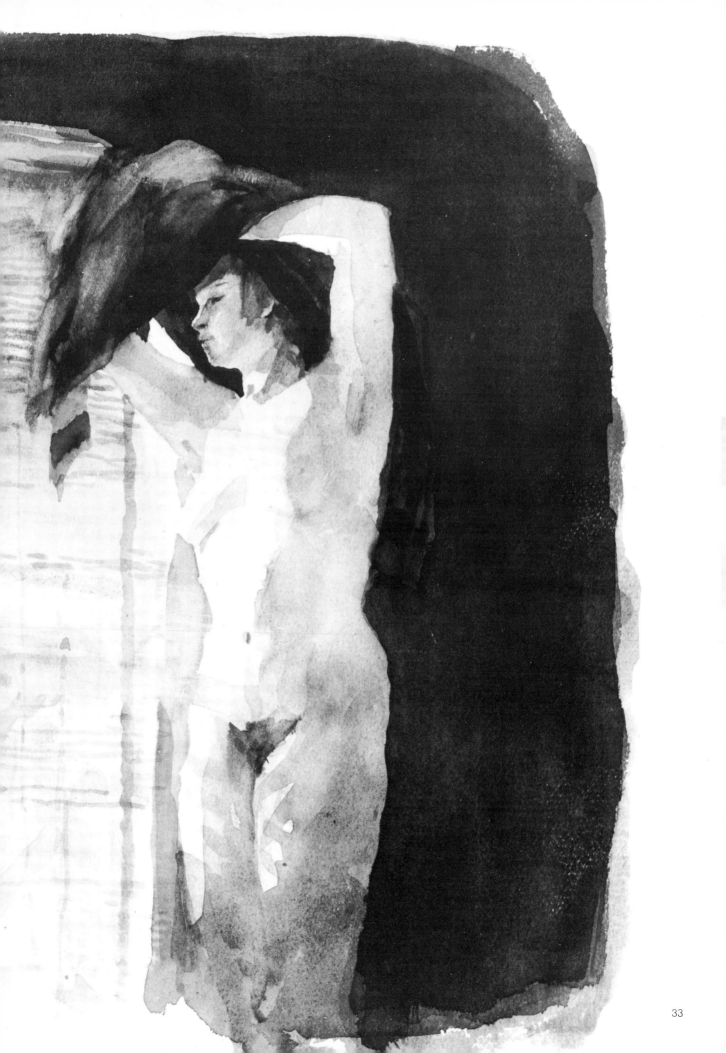

Part Two
Starting a Painting

I find discussing how and why I paint really difficult. Painting for me is instinctive and emotional. I find it easy to talk about the techniques of painting but when someone asks why I choose to paint, say, the windows in the *At the Window* paintings (pages 38–39), no amount of words describing the complex patterns of sunlight on the curtain can accurately convey the excitement I felt on seeing them and my need to put them down on canvas. Truthfully, I would rather just paint than talk about it.

Another difficulty I have had to fight in writing this book is my dislike of showing pictures while I am still working on them. I find that other people's reactions to my work affect me deeply. If they do not like a painting, I am convinced that it is no good and it takes a real effort to continue work on it because my confidence has died. On the other hand, if they like it, I feel that I dare not continue to work on it for fear I will spoil it—and so the courage to alter and change the work has been frozen. This may have been the cause of the difficulty I had in finishing *Asleep in the Sun* (page 117). I had started the painting with great excitement before the book was planned, but when the painting was due to be photographed, I felt a definite tension, no matter how I tried to ignore it. However, I think I managed to overcome this feeling—and in the end, it even became an incentive to work on it.

Working in a Studio
I know, from the days when I was unable to have a studio, how essential it is for a painter to have a room to work in. Size does not matter, but I find that I need a place to work away from day-to-day influences, somewhere where I do not have to tidy up or put things away at the end of the day. A relaxed working atmosphere is very important to me. Music, too, plays a large part in shaping my attitude to my work, enabling me to totally concentrate on a painting without disturbance from outside noises.

Starting a Painting
When I paint, I try to work on all parts of the canvas at once. I paint standing or kneeling (and if it is a large canvas, I sometimes spread it out on the floor instead of using an easel). After the quick lay-in of the composition on the canvas, I become more methodical in my approach. Rather than paint quickly, I prefer to stand back and examine each visual problem carefully before answering it on the canvas. At one time I used to apply the paint in patches, dabbing carefully related tones and colors side by side directly onto the canvas. But now I prefer to work on a painting by applying broad areas of thin paint (glazes) over the white canvas, building up the painting with the same careful observation of tones, shapes, and color changes as before. When I use this glazing technique I sometimes add a small amount of the Winsor & Newton medium Liquin. This is a gel that thins the paint while letting it retain its viscosity.

Composing a Painting
When I am working out or composing paintings, I like to stress contrasts, pitting one element against the other. In doing this, I have found the proportions of the golden section invaluable. A detailed description of this classic means of dividing a painting appears on page 104, in the discussion of *An Evening at Betty Mundy's.*

When composing pictures, the words of the painter Charles Mahoney have always remained with me. He used to say, "When you see a curve, always look for a straight." And sure enough, in many Old Master paintings, whenever you see a circle—perhaps a face (for instance, Vermeer's *A Lady at the Virginals*), next to it, adding balance and contrast, there is a straight line.

Other memories also come to mind, half-remembered quotes that have had a lasting influence on my outlook . . . Renoir, who said that he knew a painting was finished when he felt he could reach out and touch flesh, or Maurice de Sausmarez, who would tell me to paint an object as if I were touching it. This latter principle is not easy to explain clearly, but whenever I am having difficulty with a painting, when a certain part will not come right, I still follow his advice—I project my mind and try to touch the object, and it helps. I sometimes draw my own face by touch, feeling the different planes and putting them down on paper.

Painting Themes
It is difficult to assess, but if I had to express the order of importance in which I paint, I would say that the subject is the prime factor, for I have to feel deeply about the people and situations I am depicting. Once the subject is determined, I can then concentrate on the source of light, deciding how to use the patterns of light and shade to their fullest advantage in a composition. Next I concentrate on the colors in the painting and then the perspective. As I said, it is not easy to assess—it is all so nebulous.

In the paintings that follow, I paint a recurrent theme: light plus mood plus the figure. I paint many kinds of light. *Rehearsal Room*, for example, describes the bright daylight of a north room; *Annabel Khanna* captures two different moods under two different lights; *Malayan Memories* contrasts deep stormy light with warm, artificial light indoors; and *Susannah* features bright reflected light. There is intense sunlight in *Sunlight and Shadows*, deep shadow in *Away from the Sun*, and sunlight falling on flesh in *Asleep in the Sun*. Backlight is a strong feature of paintings like *Adagio, Collecting Logs*, and *Rehearsal Room*, and indoor light has inspired several paintings, among them *An Evening at Betty Mundy's, By Evening Light*, and *Winter Evening*. There the moods range from mysterious to dramatic, to the simplicity of daily life.

Mirrors also play an important role in reflecting and restating the light, often affecting the scene in a way that is totally different from the original light source. In *Reflection in a Quiet Mood* and *Su-*

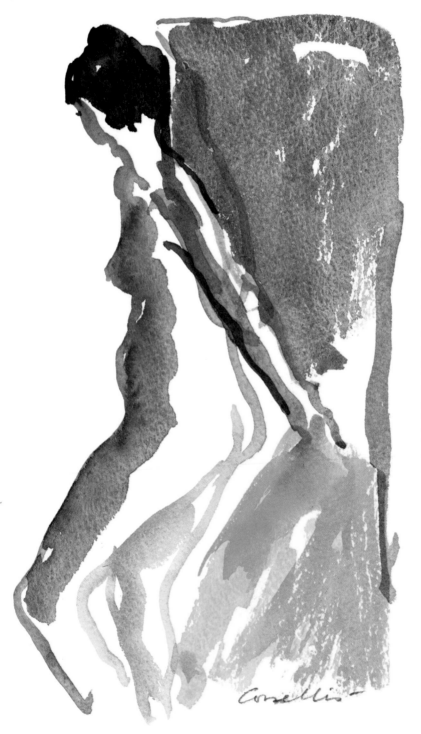

sannha, mirrors increase the contemplative quality of the paintings; in *Morning* and *Winter Evening*, they are part of daily activities; and in *Rehearsal Room*, the reflected light of a mirror acts, along with a nearby window, as a reverberating backlight.

I am also fascinated by the way the changing light affects the mood of a painting. Sometimes the light heightens the drama or mystery of the work, as it does in *An Evening at Betty Mundy's, By Evening Light,* and *Doorways*. At other times the light helps evoke a sensation of peace and distant horizons, as in *Sunlight and Shadows* and *Asleep in the Sun*. In still others—*Reflection in a Quiet Mood* and *Away from the Sun*, for example—the light seems to suggest disturbing undercurrents and tensions.

Sometimes, simply through a change in the lighting, the same scene can evoke two different moods. Both *Sunlight and Shadows* and *Away from the Sun* feature the back porch of my summer cottage, yet the former has a feeling of total peace and sunshine, while the latter, painted from slightly deeper into the house, has a feeling of foreboding. *At the Window* and *At the Window(1)* offer another example of this. Again the scene is the same, but one painting was done in the morning and the other in the afternoon, and the difference in the color and quality of the light, as well as its position, has created two different paintings.

On the pages that follow, we will examine not only how I paint, but *why*, and I will do my best to analyze my thoughts and reactions as I work. We will also see how I paint the light, how I compose each painting (including my analysis of the values and light sources), how I get ideas for painting subjects, and, most important, how I solve painting problems when a painting is not working. Paintings don't just happen; they have to be shaped and developed into strong, cohesive statements. Also, as you read, think in terms of how an artist creates a painting, molds it into a strong conclusion, and, hopefully, transforms it into a work of art.

Light on Objects

My main interest in painting and drawing has always been the way that light falling on an object or body in different ways can completely alter it. It is seldom that the isolated object itself has made me want to paint, but rather it is the object and its relationship to its surroundings—more often than not influenced by cast shadows (I tend to draw in tonal shapes and masses).

Yet despite the similarity in theme, my paintings are all different, because the light continually changes in angle, color, and intensity as the day waxes and wanes, and the natural light of day later shifts to an incandescent night light. Even slight changes in the angle of the sun and its strength modifies the whole visual dimension—the colors, the shadow pattern, the focal point. That is why I love drawing and painting in direct sunlight. It is maddening, of course, that the sun is always moving, but it is also exciting—because every few hours a different subject presents itself.

I am usually not interested in painting isolated objects but always like to relate them to something in the background. So when I have tried to draw a disciplined study of, say, a leaf, I find that I also have drawn the shadow the leaf cast on the table and the shadow that the table cast on the floor, and so on. To me, this is what painting and drawing are all about—a subject and its relationship to surrounding objects.

New Laid Eggs, 10″ x 14″ (25 x 36 cm). Artist's collection.

Morning and Afternoon Light

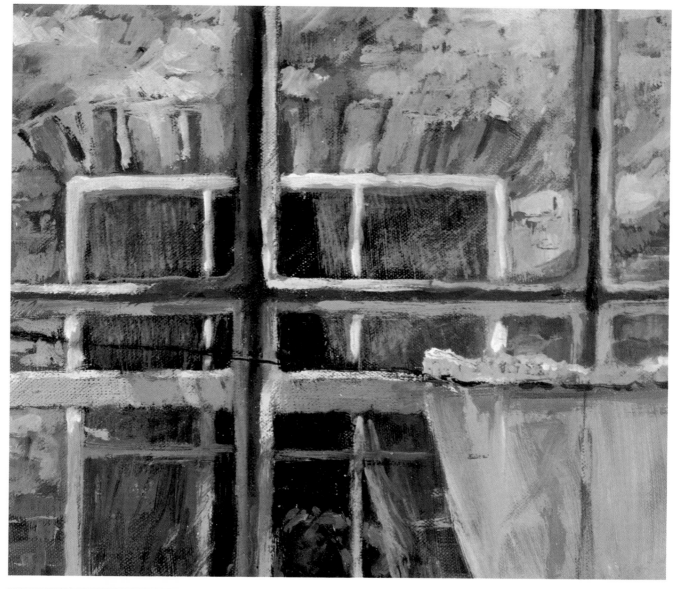

At the Window (1),
14" x 16" (36 x 41 cm).
Collection Robert Nelson.

Sometimes the most ordinary things that we see every day suddenly take on a new importance, making it impossible to imagine how they ever went unnoticed. One day I hung a net curtain on my bedroom window and, fascinated, I watched as hour after hour the colors and patterns on it changed. The tonal changes were incredibly subtle, blues to grays to yellow to pinks. I was also aware of a sense of mystery the curtain evoked and, at one point I noticed a girl standing for a moment at the window opposite and so added this figure, giving an enigmatic touch to the painting.

The change in light in the detail above has evoked different emotions and has forced a different focus and composition in each painting. In the morning, the sun shone on the bricks of the house opposite, reducing them to colorful blocks of ochres, oranges, and grays. These colors filtered through the wispy curtain that fluttered in the gentle breeze. There was a clear cool light from the sky above; it lit up the room with its crisp, clear tones. The focus of the composition was on the sharp white rectangles of the two windowpanes. The distant unlit interior opposite was dark, almost black.

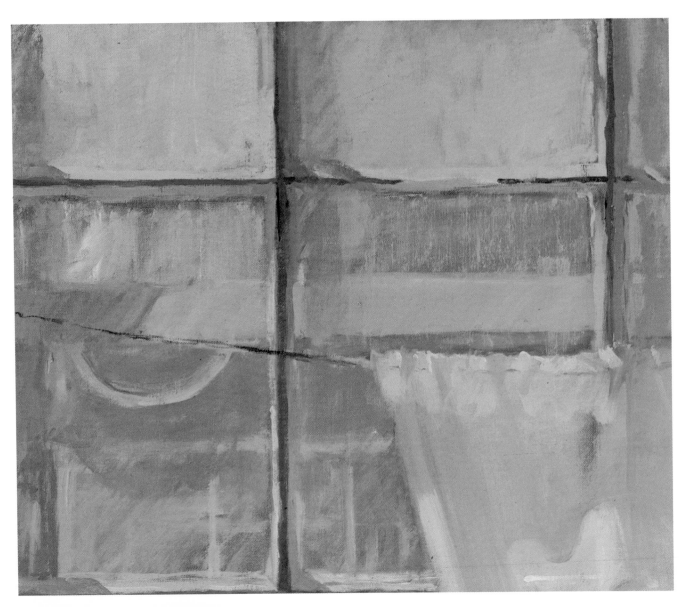

At the Window,
40" x 48" (102 x 122 cm).
Collection Alan Taylor.

It is interesting to paint the same subject at different times of the day. But when the sun changes position and the colors and values are different, it is easier to switch to another canvas rather than rely on memory.

By early afternoon, the sun was warmer and brighter. This time it shone on the curtain itself, creating a combination of bright yellow-white opaque tones and undulating pale blue shadow patterns. The high angle of the sun striking the glass made it almost opaque, causing the bricks of the house opposite to become almost invisible, and the brilliant sunlight on the curtains lit up the entire room with its warm reflections. The sunny window frame was also reflected in the window opposite, and the colors of the building shone into the facing bricks. Now the focus has shifted from the geometric angles of the first painting to the interplay of shadows and reflections.

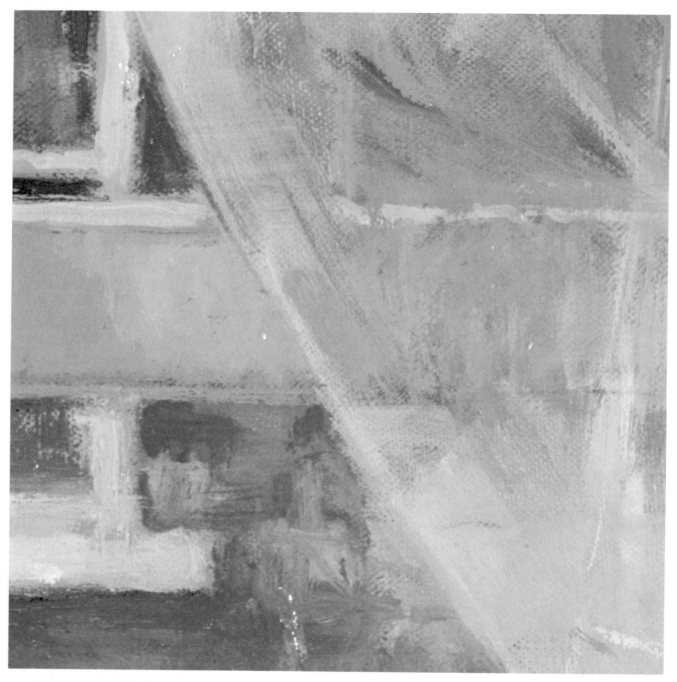

The curtain here was lit only by the cool light of the sky. Because it was transparent, the ochre bricks showed beneath the light blue-white surface, and the essential cools of the light were suggested by the blue-purple and blue-green shadows (mixtures of viridian, cobalt blue, cadmium red, and white), with an occasional bunching of the fabric and the movement of the curtain as the wind blew. The bricks were almost a dark gray ochre in the shadows under the windowsill, and the stripe of red brick (cadmium red dulled with viridian, yellow ochre, and white) added a bright note to an otherwise quiet area.

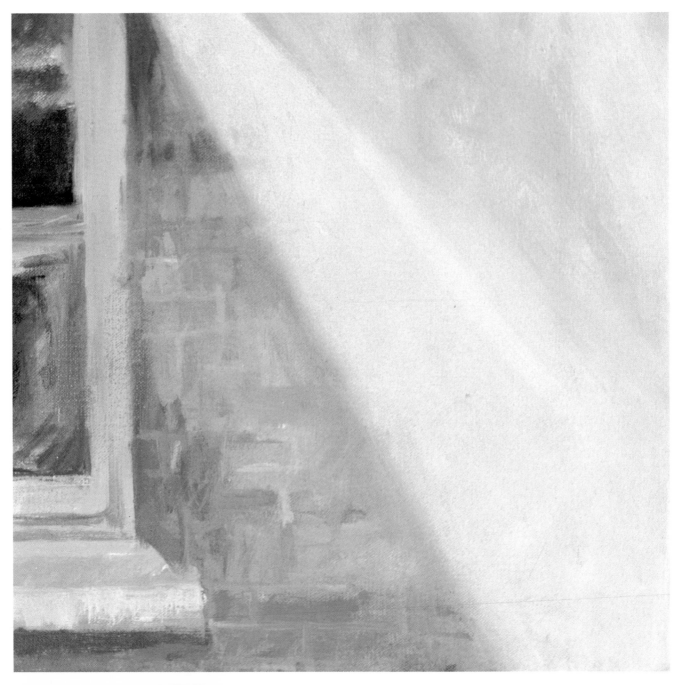

This time reflected sunlight shone on the bricks opposite. To paint them, I used raw sienna, grayed with a mixture of cobalt blue and white. Again, the touch of cadmium red brightens up the lower bricks, but this time I raised the red brick stripe to windowsill level, forcing the eye to move from there up the diagonal of the curtains on the right. I painted the curtains with subtle, light mixtures of yellow ochre, cadmium red, cadmium yellow pale, cobalt blue, and viridian, with a lot ot titanium white. The sun playing on them made them more opaque than in the first painting, so I emphasized their surface colors and shapes more. I also stressed the light and shadow patterns there and the varying thicknesses of the cloth, keeping the values light and the colors gentle.

Bright Morning Sunlight

On summer mornings, long before any idea of a painting existed in my mind, I would lie in bed watching the patterns and colors playing on the curtains and wall as the early sunshine filtered through. Subconsciously I was filing away visual experiences, noticing how the warm sun shone quite pink on the transparent curtain, and how the bars of the window cast contrasting blue shadows there. I was also aware of the quality of the light; it was that hazy sunshine of early summer mornings that shines softly and warmly before the brightness of noon has a chance to bleach the colors. At midday, when the sun would shine flat and square on the floor, I could have had an entirely different and exciting composition, but at this early hour, I was impressed by the dramatic directions of the shadows, their differing patterns and angles, and the subtle interplay of color temperatures.

As I continued to think about the composition, at first I pictured only a wall behind the girl. Next I decided that the flat space was boring and considered adding a closed door. Later (perhaps I was influenced by Vermeer and other Dutch old masters whom I admire), I realized that a half-open door would create a sense of mystery and expectancy (you'll see that I use this theme of the half-open door in several other compositions in this book). One day I discovered just the right door and angle of light I wanted at a friend's house, and did some drawings of it there. Once I had studied the way the light struck and how the colors reacted, I could easily transfer the information to my painting. (At one point, I even added the figure of a man in the room beyond, but took it out because it was too distracting.) I also made a detailed study of the net curtain in pencil and watercolor. Interesting patterns were created by the warm, glow that reflected from the unseen brick wall in the garden, contrasting with the cool shadows that the window bars cast on the curtain. Since this effect lasted only about an hour, I had to be up early to catch it. When I had worked out the ideas for the painting in my mind, I started work on a large canvas, without preliminary drawings of the painting as a whole.

I roughed in the basic composition with a 1½" (38mm) housepainter's brush and a diluted wash of raw umber. When it was dry, I scumbled layers of fairly dry paint onto the canvas, rubbing them in thinly, relating and contrasting the tones in various areas. I continued to scrub on thin glazes of paint until I had achieved the

Morning, 50" x 60" (127 x 152 cm). Collection Gordon McDougall.

right effect. Since few areas were completely cool, these layers of warm and cool glazes expressed the quality of the light and its complexity particularly well. The cool shadow areas, with their bright warm reflections, were especially difficult to assess and paint.

The basic composition, values, and light sources of the painting are analyzed in these small tracings. If you compare them carefully with the finished painting, you will see how I translated my thoughts into paint.

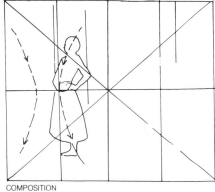

COMPOSITION

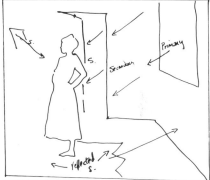

LIGHT SOURCES

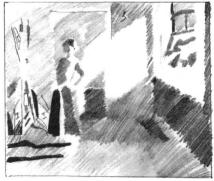

VALUES

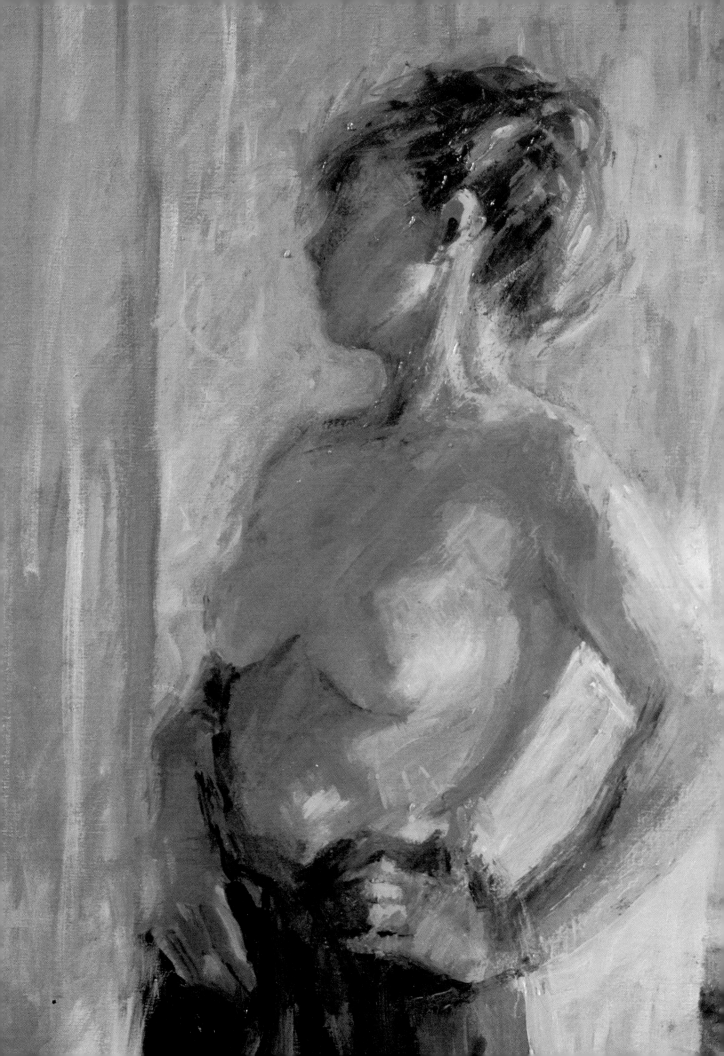

The girl's head was turned away from the window at an angle, and I painted her profile, which was mostly in shadow, almost without changes of color. The colors there were further complicated by the warm light of the sun reflected from the mirror onto her body. However, after intense scrutiny, I did my best to paint what I saw.

I looked for both similarities and contrasts in the shadow patterns. For instance, I noticed that the wavy shadows on the curtains were repeated in the shadows on the girl's body. I also tried to capture the lost-and-found, flickering quality of the light on various objects, particularly on the paneled door. The inner edge of the door near the head was quite sharp, while higher up, colors and tones merged. I suggested the panels on the lower part of the door with light tones but, as the light changed on its highly polished surface, I used increasingly darker tones. For example, I painted the shadowed upper part of the door (see full painting) with cerulean blue and rose madder genuine, and expressed the warmer tones below it (shown here) with cerulean blue and burnt sienna, adding terre verte for the shadows and touches of cobalt blue for the highlights.

This area contains one of the most complex patterns of values and angles in the painting. When I first thought about the painting, I realized how much more interesting it was when I left the top of the window slightly open because then the blue shadows waved in broken lines in contrast to the severe horizontal parallels of the window frames. The white edges of the window bars also played an important role in the composition, stopping the eye at the edge of the painting while directing attention and interest to the window area.

The white curtains also help to heighten the contrast between the light outside and the shadows in the room—an effect strengthened by the dark line of bricks outside the window. For a transparent effect, I rubbed burnt sienna (reflected by a brick wall from the garden outside) onto the canvas as a base, wiping away what would later be the blue pattern of the shadows. Then I painted the shadows carefully, with sweeping strokes of thin cobalt blue. The whole painting was a combination of such seemingly casual areas of brushstrokes and some very carefully placed details, such as those on the windowsill and lower edge of the curtain, and the barely noticeable bars behind it.

The bright sunlight brought out changes of color and tone in the white wall. I seem to remember this wall being in need of a coat of paint, and the effect of this scrubbed-on, whitewashed look, with its underlying changes of color, was what I was trying to achieve. I painted it with thin washes of burnt sienna and ochre and later scumbled on cerulean blue.

Artificial Light

I had wanted to paint a large painting under artificial light for some time, as well as an ''evening'' version of the *Morning* painting shown earlier, and finally did so here. The artificial light in this painting comes from two places: a strong light behind the door and a small spotlight just inside the larger room on the right. I shone this spotlight on the door but not on the figure, which is lit only from the left. The reflections from the fire of the gas heater fall on areas of the figure and sides of objects that are hidden from view and convey a sensation of warmth, despite its comparatively small size. The fire of the heater seems even warmer because it is surrounded by its complement, blue.

The incandescent light here is far warmer than the light of early morning in the preceding painting, and there are fewer shadows in this well-lit room. The tones on the figure are also more golden than those on the figure in *Morning*. The feeling of warmth of this painting is intensified by the movement (through the open door) from a larger space into a smaller, more intimate room (and a physically warmer one too, because of the heater). This painting is, actually a view of our bathroom as seen from the bedroom. (You can see the reflection of the bedroom in the mirror.) The wallpaper on the right is also in the bathroom, but it is reflected in the mirror on a smaller scale (because of its distance), which gives it an almost oriental effect.

The composition of the finished painting is strongly divided by vertical lines—the bedroom walls and door. But the eye is drawn to the figure by the diagonals on the door and pattern of the wallpaper on the right, and is held there by the strong line of the arm of the wicker chair and its upright diagonal green drapery. In a more subtle way, the spotlighted area on the door also helps point to the figure. Once in the room, the strong horizontals of the mirror and, to a lesser extent, the ceiling—they actually form a square—help stabilize the eye and rivet attention on the woman and her reflection in the frame mirror.

Winter Evening,
45'' x 50'' (114 x 127 cm).
Collection Kenneth C. Slater.

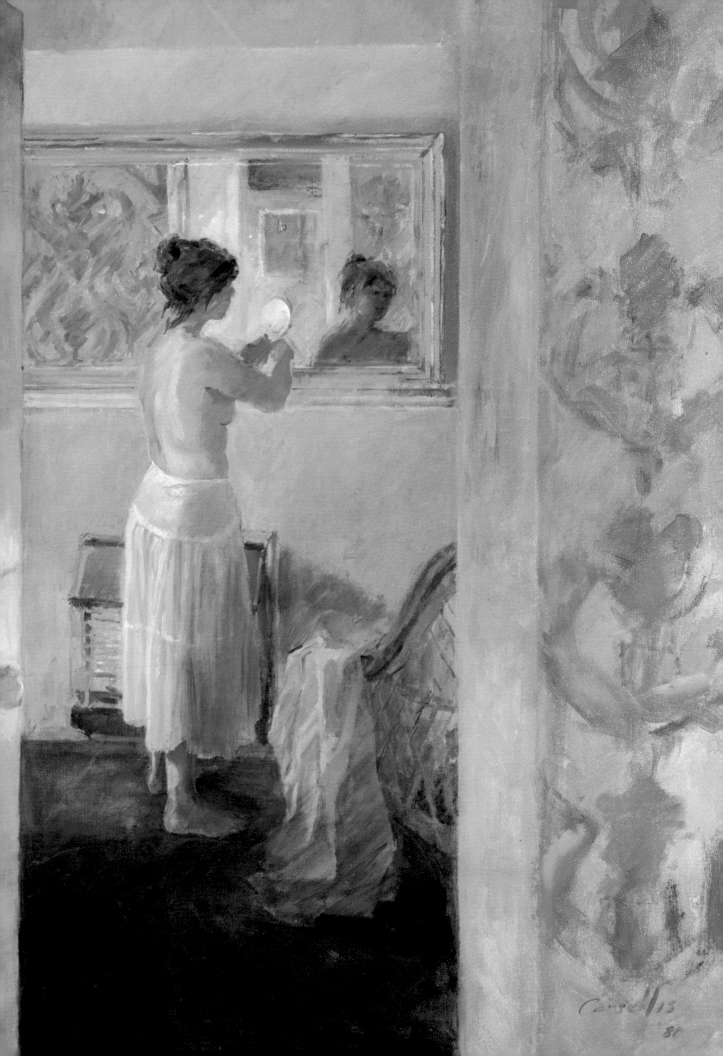

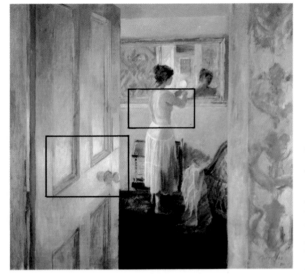

To link the scene together as a whole, I repeated the shadowed colors of the flesh—cobalt blue, rose madder, and yellow ochre—in the doorknob and shaded frame. I played this against the spotlighted door, with its bright blue-white tones tinged with orange—the same tones I had used on the petticoat in the light (and tones I was to repeat again in the mirror). Further below on the door, as the amount of light decreased, I picked up the colors of the orange-green heater cover and the shadowed tones of the green drapery (see larger painting). Note the lost-and-found lines in the door frame. They add interest and excitement to the painting and heighten the sense of reality.

The incandescent light shining on the figure here is deep and warm—a golden orange. (The light in *Morning* was harsher and whiter, and its yellow, pink, and even light blue tones were more bleached out.) The fleshtones here range from deep rosy beiges in the shadow—mixtures of rose madder, yellow ochre, and cobalt blue—to bright oranges and yellows in the lighted areas—mixtures of yellow ochre, burnt sienna, cadmium red, and white. In *Morning*, on the other hand, the fleshtones were blue-pinks and greenish yellows. I also cooled the flesh here with subtle, gentle additions of terre verte rather than with the cooler cerulean blue I used in *Morning*, though I deliberately brushed diagonal lines of cerulean blue across the face in the mirror here, because I wanted it to appear more distant—that is, mirrored rather than real.

The color of the models' clothing in both paintings also affected the appearance of the fleshtones. I related the golden tones of the model here to the gentle, light cobalt blues and viridian greens in her white petticoat by adding touches of the flesh colors to it. I added cadmium orange and burnt sienna in the light, and a combination of cobalt blue, burnt sienna, and white in the shadows. In *Morning*, on the other hand, the complex tones of the flesh were played off against the harsh, dark tones of the blue-gray skirt.

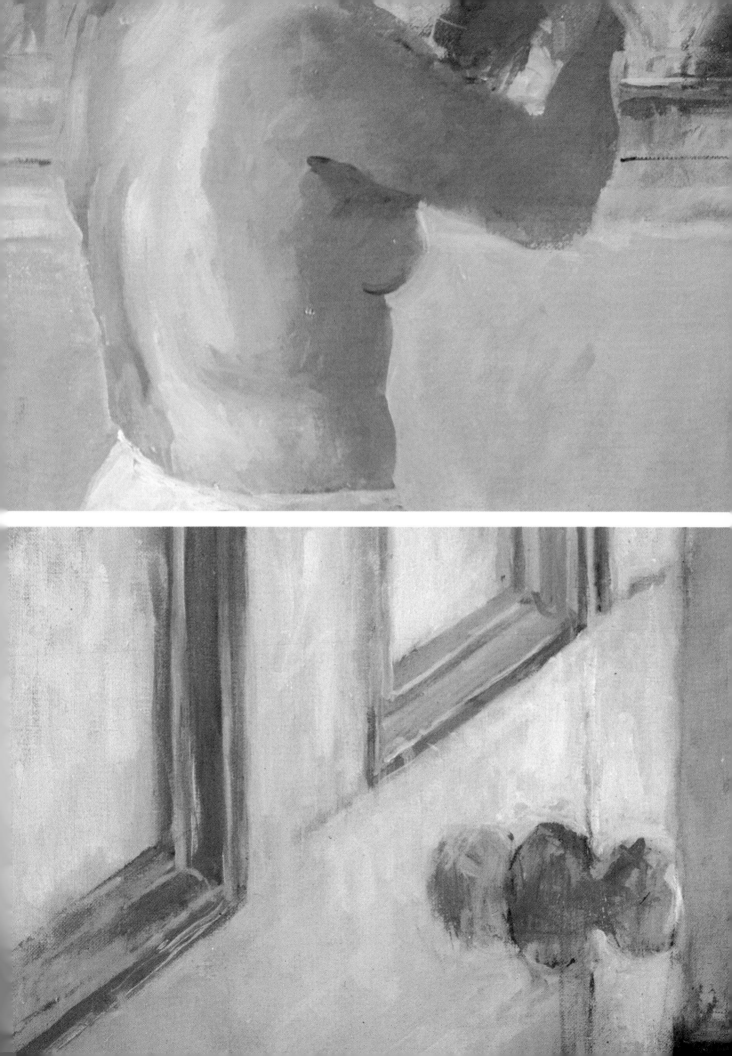

Transparency and Soft, Filtered Daylight

For some time, I lived in a large, old Victorian house with strong, thick walls and well-proportioned windows. In fact, everything about the house was well-built, spacious, and inspiring, including the small washroom behind the kitchen. One day, I walked into the room and was immediately struck by the strong light that came from the window and flickered through a newly ironed dress hanging from the drying rack. Behind this gauze-like dress (at odds with its surroundings by the very delicacy of its material and its elegance) was a crisp white shirt, which filtered the light in an entirely different way. This bright daylight was a major factor in my reaction to the scene. Had the room been dark and the clothing less transparent, the surrounding tones would have been harsher and more contrasting, overstating the relationship between the values and losing the subtle balance between the tones.

In selecting my subjects, I often conjure up distant memories, unusual visual experiences over the years, moods that can be relived, triggered by something seen in the past that influences what I am currently seeing. And that is exactly what happened in the painting of *Salomé*. Years ago, as a child, I remember coming into the house from the fields and being told to remove my muddy clothes in the washroom first. The memory of pulling shirts over my head and standing on the stone floor still lingers here, along with recollections of fleeting glimpses of long dresses hung up to dry, with the bright light filtering through them. I called this painting *Salomé* because I felt somehow that Salomé must have pulled off her clothing just like this woman before getting into her beautiful veils and dancing for the king with such terrible consequences.

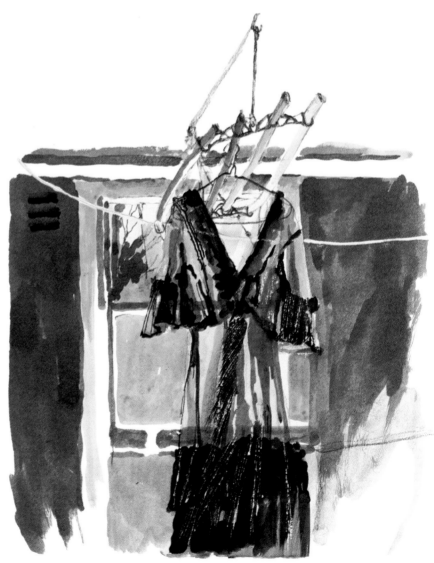

Preliminary Sketches

By looking closely at my preliminary sketches, you can follow my thinking as the painting gradually took shape. For example, the figure on the right was originally a woman ironing clothes, but I decided to change it to one of a woman undressing that I found in a drawing in my sketchbook. The flagstone floor was another addition, based on a recollection from childhood.

I also juggled with the composition, working out the geometry of the painting on paper. For instance, I wanted to show the contrast in form between the flat, ang-

ular dress and the soft, three-dimensional figure. Also, I first drew the rails of the drying rack straight-on and had the ropes go out of the top of the painting. But it didn't look right, and I found that by lowering the rack and its pulleys and by tilting the rails a little, the whole composition worked much better.

I also wanted to keep the intensities of the colors low and warm throughout to achieve the effect of a light-filled room. The three diagrams on the next page chart the composition, values, and light sources in the painting.

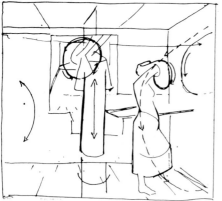

COMPOSITION

LIGHT SOURCES

VALUES

For this painting, my palette consisted of titanium white, cadmium yellow pale, yellow ochre, cadmium red, rose madder, alizarin crimson, burnt sienna, raw umber, French ultramarine blue, cobalt blue, cerulean blue, terre verte, viridian, and lamp black.

I decided to work on a large canvas, and began by laying it on the studio floor and rubbing a very pale solution of burnt sienna, yellow orchre, and terre verte over its surface with a rag to reduce the brilliance of the white canvas. This created a layer of subtly differing glazes that made a lovely toned ground to work on. When the canvas was dry, I blocked in the basic shapes with a weak tone of raw umber, which I spread on with an old cotton cloth folded into a pad. I filled the canvas as lightly and quickly as possible, keeping the forms simple.

As I added the objects in the room—the dress, window, and rails—I kept their values balanced, constantly comparing their sharp, dark tones to each other and to the subtle tones of the lightly glazed walls and ceiling. As the painting progressed, the composition became more complete. The air vent in the upper left was put in, scrubbed out, and put back in again according to how I felt its presence affected the overall balance of the painting. I had earlier omitted a washing machine and a few brushes and brooms because I felt that they had not helped the composition of the painting. But the washing line, which ran across the top of the painting, was left in because it described the depth and breadth of the room so well. I depicted the skirt sharply in some places and more loosely in others, summarizing its impression with a minimum of realistic detail.

Like many painters, I am never quite sure when a painting is finished. My acid test is to stand it at the end of the bed at night and study it before going to sleep. Then, when I wake up, I study it again in the morning and, if there is more to be done, I can usually see it then. I also often hold it before a mirror to check composition and proportions—and seeing it in reverse reveals weak or unfinished passages, too. Finally, I ask myself if I would like it to be seen by someone whose opinion I respect. If it passes this test, it's finished!

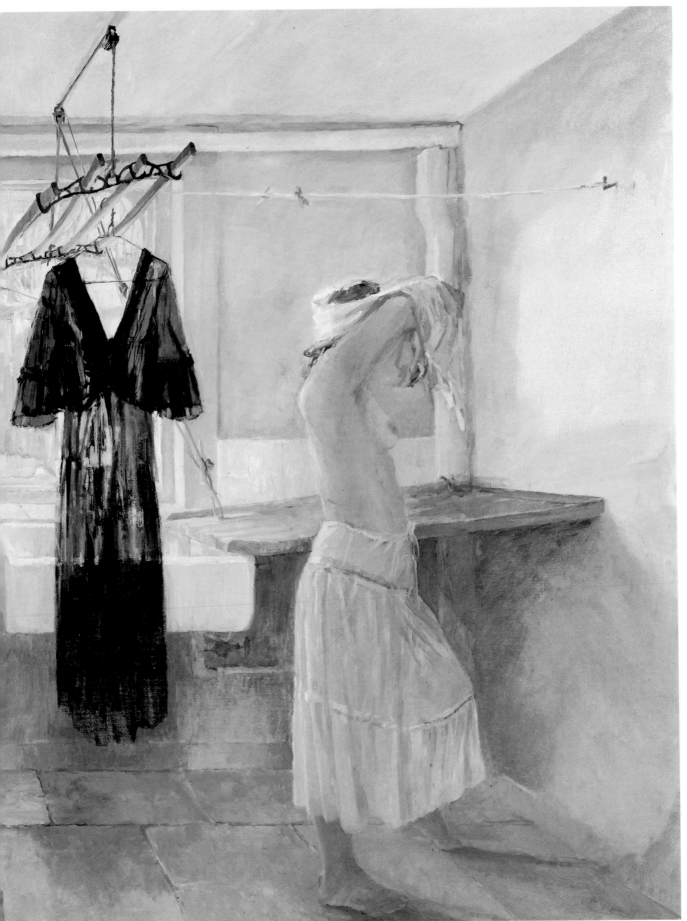

Salomé, 50″ x 60″ (127 x 152 cm). Collection Kenneth C. Slater.

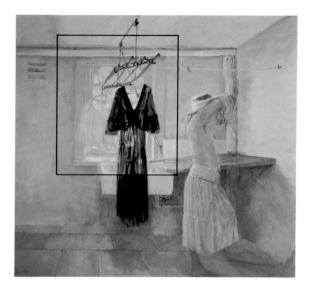

The strong light that came through the window flickered through two objects—a thin, black dress and a soft white blouse. The jagged, bluish spikes of light that came through the folds of the dress were similar to the softer, more rounded, violet branches of the trees outside. To intensify the effect of the strong light, I deliberately bleached everything outdoors, particularly the branches, keeping the darkest tones indoors. I painted the dark rack with crisp, hard edges, while I painted the walls and ceiling with light washes of color, thinned with a great deal of turpentine. The transparent quality of the dress was achieved by painting the background first. When it dried, I brushed thin glazes over some areas, leaving others almost bare and darkening some lines heavily where the folds of the fabric blocked the light. I treated the white blouse similarly. I also placed the coolest colors in the painting—light, subtle tints of violet and blue—in the white areas in the painting (such as the skirt and sink) at the window, and on the floor, which runs the gamut of tones from warm to neutral to almost cold.

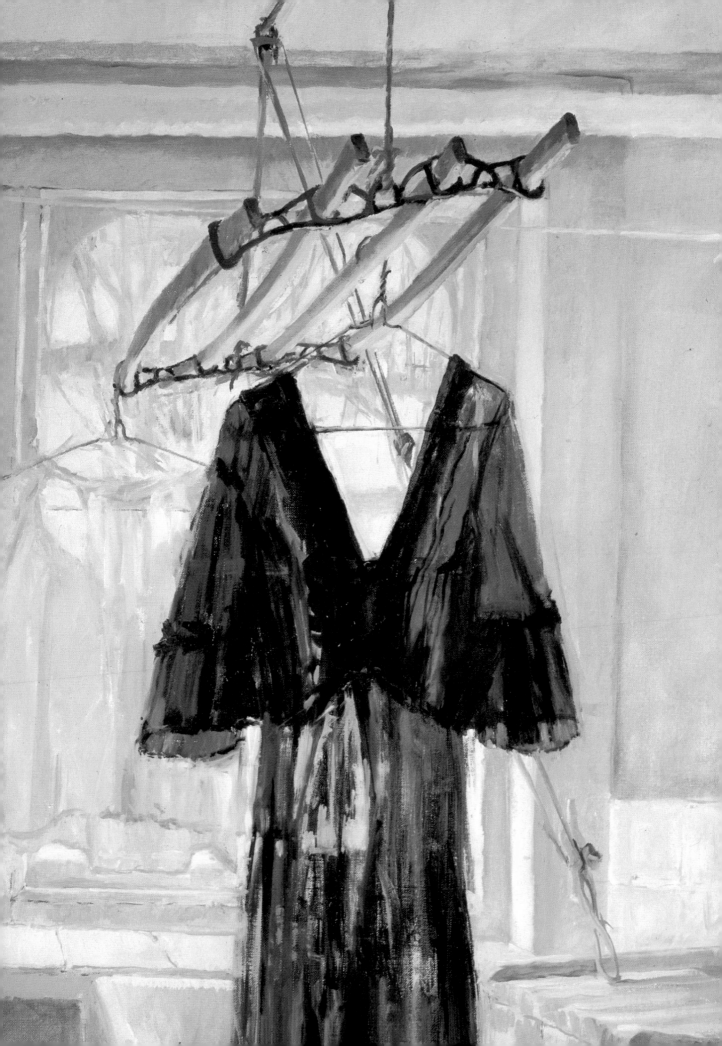

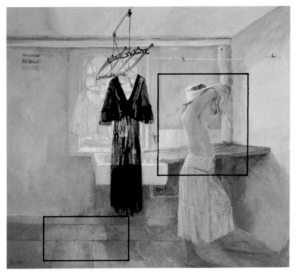

As I explained earlier, I built up the textures of the walls, floor, and ceiling by rubbing on a weak solution of color with a large wad of an old cotton T-shirt. I used this cloth as I would have manipulated a brush, and its texture gave a certain variety to each broad stroke. Had the cloth produced more textured strokes, the effect would have been too stylized for the painting and it would have destroyed the beauty of the old distempered walls. This soft, warm color, which gets slightly cooler on the ceiling and near the window, expresses the luminosity of the room more than any other factor. Although it looks like I used a lot of titanium white to get this effect, the light is merely the white of the canvas below it. Had I used white paint, the surfaces would have looked pasty and lifeless.

This painting is unusual in that, despite the title, the focus is not the figure, but on the transparent clothing at the window. Yet the figure plays a pivotal role in the scene. Without it, we lose the story, the tension; the painting becomes merely a description of a room and the light—not enough to sustain interest for very long.

I kept the tones of the figure subdued and similar to the surrounding walls, and repeated the soft interplay of light and shade on her petticoat and shirt. The shadows on her clothing are slightly more purple than the hanging white blouse, since they are farther from the window. Note where the horizontal line of the wall intersects her body. I deliberately stopped the ochre wall at that level for greater interest and a better geometrical shape. The whole room is filled with these intersecting angles, circles, and rectangles. I was also drawn to the arch of her back and the diagonal her raised arm made as it intersected the square of the wall. This relationship was strengthened by running the edge of the shirt she was removing along the border of the drainpipe to move the eye deeper into the shadowed recesses of the room.

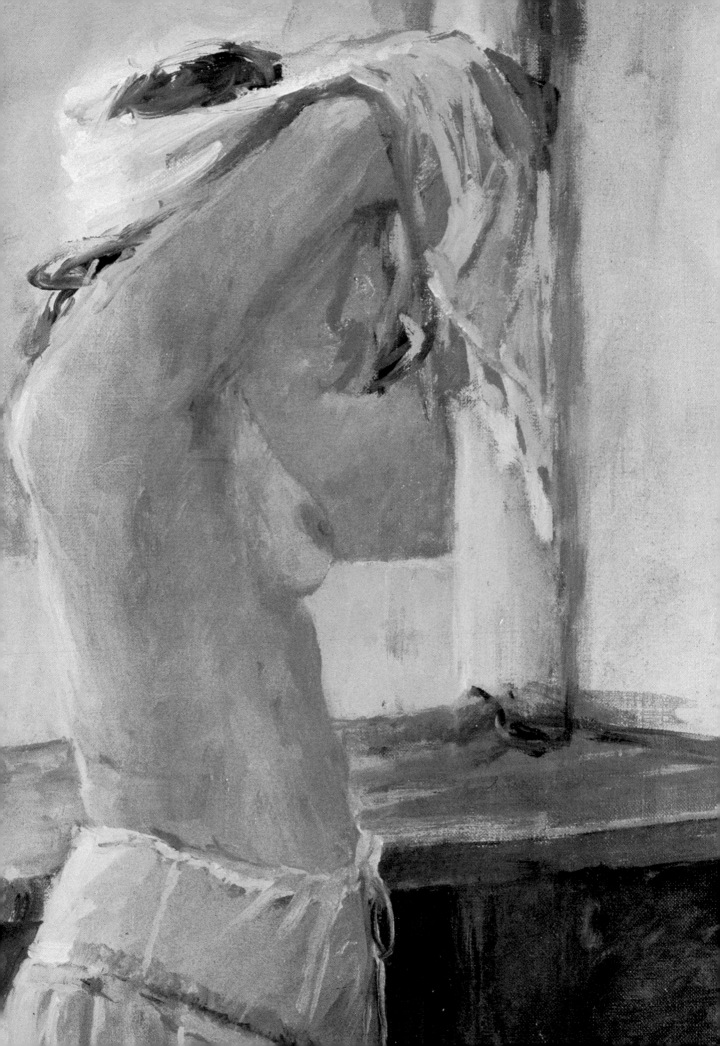

Bright Summer Light

Sunlight and shadows is a theme I love and paint over and over again in all its varying moods and intensity. This is what my painting, my way of seeing things, is all about. Perhaps if I lived in a climate of everlasting sunshine, I would not feel the same. But I wonder.

This painting is based on a view from the small wooden cottage we have by the sea. When the sun shines there, it is as if we were in the south of France; when it rains, it's Siberia. This was one of those rare hot summers when the sun had bleached all color from the stone. I wanted to try and paint that heat, the pale wall, the girl with her hair protected by a scarf and her body covered against the sun. I also wanted to show the vast expanse of sea stretching away to the horizon, with the complex pattern of shadows, and the lines of door and balcony leading to the distance—all accentuating this feeling of space.

Apart from the inside of the umbrella, the painting is in a narrow, high-key tonal range. The colors—pinks (alizarin crimson and cadmium red) and burnt sienna, and the cool viridians, cerulean, and cobalt blues—were all bleached by the sun. The shadows inside the house were kept green and cool while outside they were made purple and warm.

The sea was a shimmering mass of color, the horizon ill-defined in the heat. I painted the sea again and again, with layer upon layer of varying shades and hues of blue. It was difficult to keep the color interesting and varied, though I had to in order to prevent it from looking like a blue wall. I also had to give it subtle

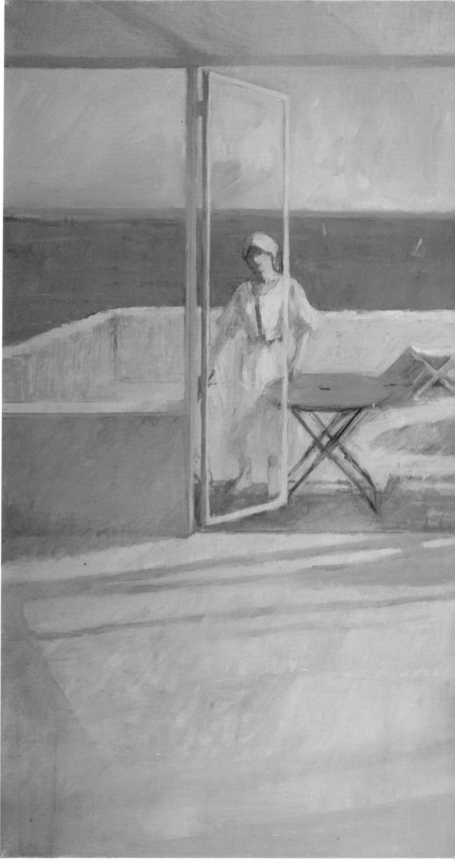

Sunlight and Shadows, 50″ x 60″ (127 x 152 cm). Collection R. Slater.

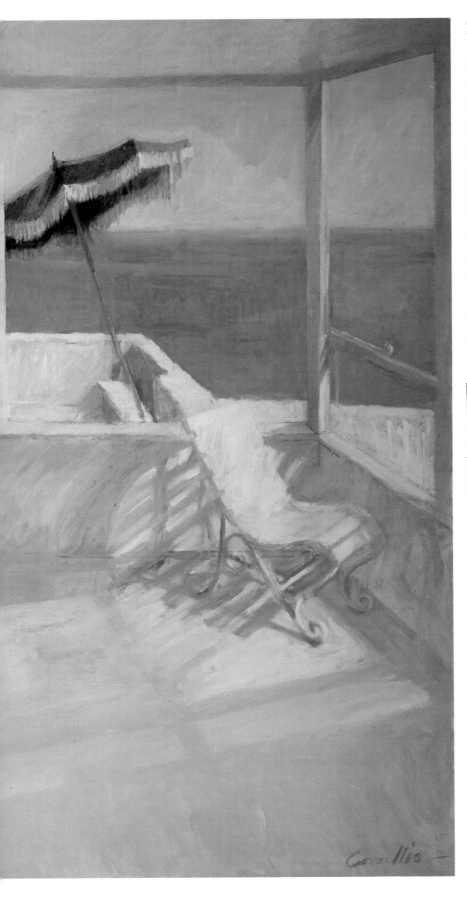

gradations to suggest a feeling of distance.

There is a complicated pattern of rectangles here, and the shadows on the floor make the eye zigzag across the painting in an upward spiral. The diagonal line of the chair forms a line that continues into the umbrella stick and leads the eye into the upper area of the painting. This line makes an interesting triangle with the opposing line of the girl's straight arm and the table legs, intersected by the slightly diagonal shadows on the floor. It also echoes the shape of the sailboat.

I think that the sailboat, insignificant at first glance, is very important. All lines lead to it in the end; if you were to take it out, I feel that the painting would lose something.

I was careful not to clutter the large painting with too many inessential items, such as beach towels and other summer clutter. It was a great temptation to add these objects, but I resisted it because I felt that it would have subdued the feeling of great heat.

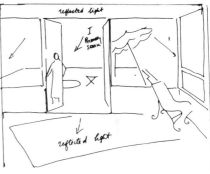

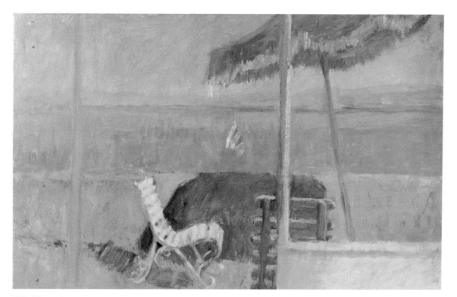

Oil Sketch

The boat was even more prominent in the small oil study shown above than it was in the final painting. You can see how its stripes were echoed in the slats of the two chairs and in the fringe of the umbrella. I painted the scene with short, vertical brushstrokes that repeated the movement of the stripes.

The surface textures of my paintings are important. I don't like a smooth oily finish; I like to see the brushstrokes. Yet I find that a buildup of great blots and ridges of dried paint, a heavy impasto, distracting though sometimes unavoidable while I am working on a painting.

In this painting, surface texture played an important role in expressing the sensation of strong sunlight, especially on the chair. At first I tried to paint the chair with a brush, using thick, white paint. But I just couldn't get the effect of solid-looking strength I wanted. Then I tried pressing the paint on firmly with a palette knife, scraping off the surplus so that only a thin film remained, and drawing the slats of the chair into this with a fine brush between scrapings. It worked. I repeated the process a number of times, with the result that the chair looks firm and the slats are just suggested.

I painted the shadows in thin washes with a large, floppy brush, almost like a watercolor brush. In some places I rubbed on an undercoat of pale yellow ochre with a rag and drew over it again with a brush.

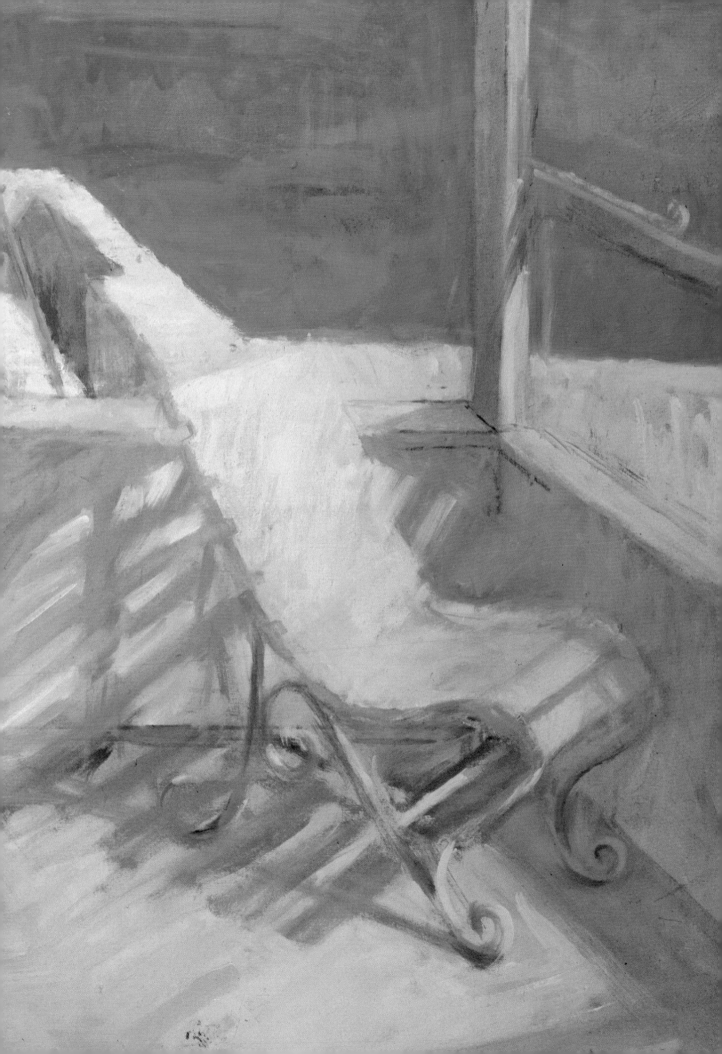

Strong, Dramatic Backlight

I have always known that light shining into darkened interiors can create exciting compositions. One winter while I was staying with friends in their cottage in Suffolk, I noticed how the pale afternoon sun shone into their hallway and cast a beam of light into the inner room. It was almost jewel-like in its intensity. I decided to arrange a composition based on this simple interior.

Preliminary Sketches

At first I more or less drew the scene as I saw it—the oriental carpet with its squarish patterns and vertical border leading to the rectangular dresser and paintings, and to the open door and hallway beyond, with its shelves, mirror, boots, and red-curtained window. To heighten the effect of the distant light and move the eye there, I darkened the interior room by painting the walls a dull brown mixed from burnt sienna and ultramarine blue. I also placed the bright red boots in the distant room.

After analyzing the first sketch, I found that there were still many elements to work out, and so I began a second sketch (below right). For example, the first sketch seemed to lack excitement or "punch." The room was empty and even the sparkle of the patterned carpet was not achieving the effect that I wanted.

Since I feel that the human figure, even if it is virtually undefined and merely symbolic, adds considerable interest to even the most quiet scene, I placed a man in the doorway and moved the window to the back wall so it silhouetted this half-hidden figure. I also moved the door almost to the center. Then I accentuated the squares, repeating them in the window and windowpanes, bookcase with its shoes and boots, green and brown rectangular rugs, and square mirror on the wall. I also placed a square white light switch just inside the room on the left.

Finished Painting

Although both sketches were unsuccessful in themselves, each contained elements I wanted to develop further, ideas that sparked additional ideas. For instance, in Sketch 1, I liked the distant perspective and the oriental carpet, which added vertical drama and balanced the smaller rectangle of the doorway in a larger space. I also liked the idea of having a strong light coming from a distant source (I played with this backlight later in *Adagio*). In Sketch 2 I liked the idea of framing a figure in a doorway with light, as it was on the threshold of entering another room. I also found the repetition of square and rectangular shapes satisfying, though I changed the bookcase

back to a dresser because I thought a dark square shape there would balance the figure better.

But other elements had to be changed. I decided not to cut the figure in half, and changed the distant window to a door in order to silhouette more of the figure. I liked the idea of the strong backlight, which emphasized the general shape and lost specific details of the features. For the figure, I decided to paint a friend coming through the door carrying an armful of logs for the evening fire. I particularly liked the way his enveloping arms echoed the pattern of the oriental carpet. I left the inner walls dark but changed the brown to a more interesting olive color—the same as the shirt in shadow. I created additional color interest by toning the entire canvas a bright cadmium orange and working the rest of the colors over it in loose, scumbled brushstrokes, letting parts of the underpainting show at times. The bright tones of the outdoor light were reflected in the intense yellow-white tones on the open door and in the mirror, fading to a dull blue-gray by the time it reached the floor. (I painted the same door in a watercolor sketch for *An Evening at Betty Mundy's*, again taking advantage of its dramatic potential by playing up the deep shadow shape behind the door.)

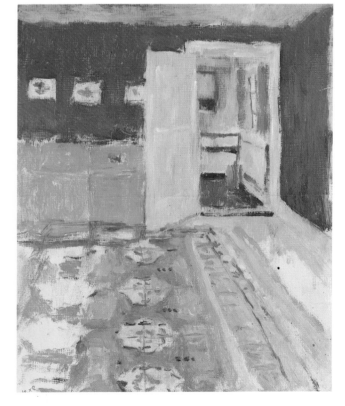

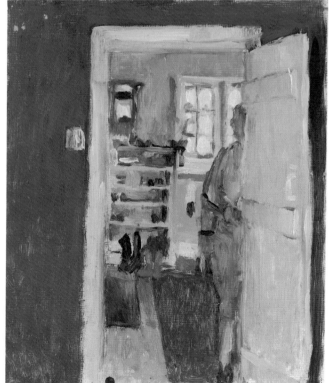

Collecting Logs, Suffolk, 12″ x 14″ (30 x 35 cm). Artist's Collection.

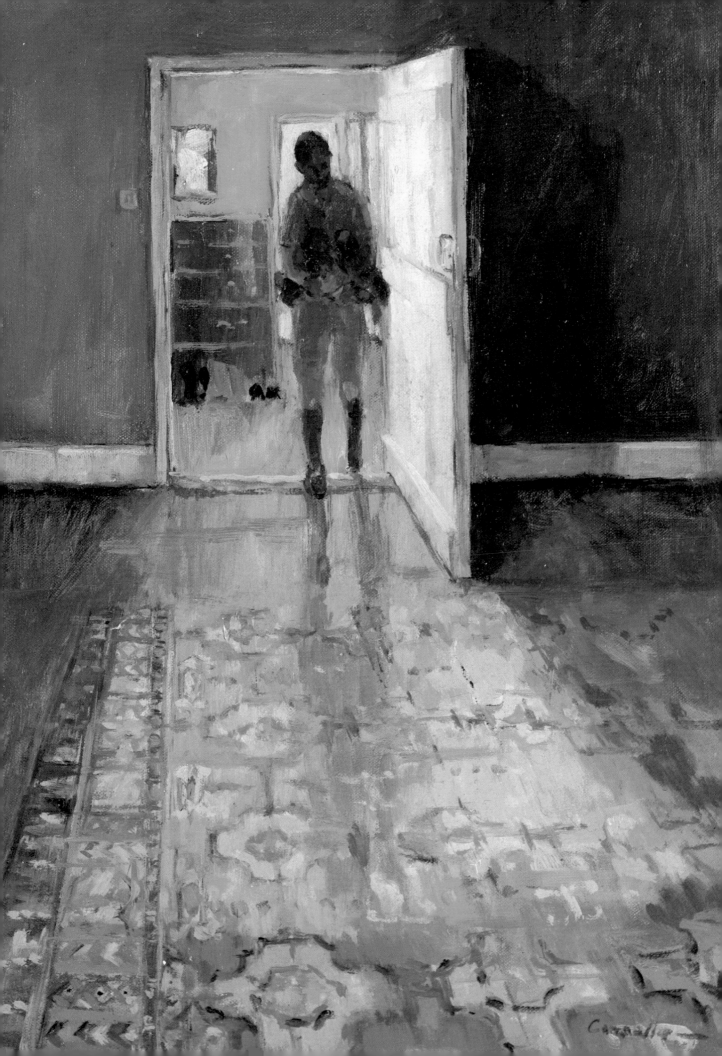

Reflections and Stormy Light

My husband and I were in Malaysia, in a hotel right on the beach. Like many tropical areas, almost every late afternoon there was a storm. It lasted only about an hour, but it was a regular occurrence. The sky would become an angry, dark color and the wind would bend the palms almost to the ground. And it would become so dark that the lights would have to be turned on in all the houses, while the rain poured down in sheets.

On this particular day, the heat was so intense that the doors on the veranda were still open, despite the threat of rain. As I sat on the veranda watching the reflections of the beach in the windows, I noticed how the palms behind me bent toward the door. The warm colors of the room could be seen wherever the dark reflections of the palms appeared, and they contrasted strongly with the gray reflections of the threatening sky.

When I looked at the room, the first thing I noticed was how its warm tones shone between the cool reflections in the windows. I thus anticipated a painting in essentially oranges and blues, emphasizing that contrast. In addition to the complementary colors, edges and values were also important. The dark ceiling, the warmest area in the room, cut sharply against the light blue of the upper door. As the eye descended, the lost-and-found edge of the door was less sharply defined by the window at the rear of the room, but it was renewed again by the sharp, dark area of the floor, then lost against the light floor boards.

Malayan Memories,
28" x 35" (71 x 89 cm).
Artist's Collection.

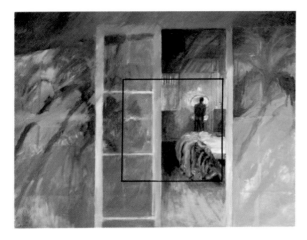

Although the main light came from the gray overcast sky and was reflected in the glass and on the floor near the open door, a weak daylight also shone in the distant window, creating an interesting, small rectangular shape. But its light was quite overpowered by the bright incandescent light over the mirror above the sink. My husband, who was quite suntanned by then, appeared even darker because he was silhouetted against that light. The result was a backlit effect (the light from the door was too far away to affect him). The light in the room seems to surround the oval shape of the mirror in concentric circles, having the effect of a small area of bright light that heightens the strength of the darker areas in the room, made even darker by the impending storm.

I particularly liked the pattern of the bright Malaysian sarong that was casually thrown across the bed. Its jewel-like colors presented a strong contrast to the dramatic grays of the exterior reflections.

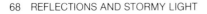

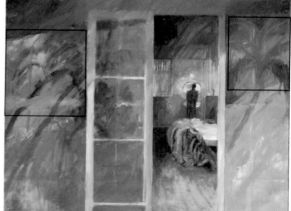

The palm trees formed an essential part of the composition, leading the eye directly to the figure at the center of the composition. Although the painting appears to have an overall grayish cast, there are a lot of patches of warm, even, bright, color here. I scrubbed a base of burnt sienna, cerulean blue, and French ultramarine mixed with white into the surface of the painting with a rag or soft brush. The warm section behind the door also contained some alizarin crimson, which produced the violet tones. In the full painting, touches of permanent green light describe the grasses and the warm ochre reflection of the beach curves into the distance.

The tree branches curve back into the center of the painting, focusing interest on the figure in the interior. The light of the sky is so intense that it covers the giant, cross-hatched pattern of the window completely. The quick diagonal brushstrokes of light violets, red purples, and muted, light yellows that are scumbled and layered across the glass express the changing light of the sky.

A Gradually Deepening Light

I have always admired seventeenth-century Dutch paintings of interiors, especially those of Vermeer. Several years ago, upon seeing the complicated composition of Vermeer's *The Love Letter* in the Rijksmuseum in Amsterdam, I was particularly impressed with both the exquisite harmony of the doorway, chair, and foreground wall and the skillful spacing of the floor tiles and household objects, which create a great sense of depth. Vermeer's *Young Lady with a Necklace* has also fascinated me. In it, a young girl faces a window; the blank wall behind her occupies almost three-quarters of the painting, and the deep black cloth in the foreground at the right balances the composition in an amazing way. I have tried to capture a similar feeling and mood in *Reflection in a Quiet Mood*, although I started with quite a different intention. Originally, I was interested in the contrast between the very dark room in the foreground and the light room beyond. I pictured the distant room as having a doorway leading out to a sunny garden with some children playing in it, an open, happy, domestic scene. But instead, I found myself painting out the sunny garden, enclosing the room beyond, and creating a quiet, still painting where a woman seems to be enclosed in her own world of silence and seclusion.

My aim in painting interiors has always been to raise them from the commonplace and familiar into an unusual visual experience. Although my ideas are constantly changing, I still find the mystery of evocative shadows and dark places behind doors very exciting. But I also try to add some special tension. I want to make the viewer stop and look, and want to look again—to question why a figure is in a particular position or what is behind a door or to identify with a particular mood or experience. Nonetheless, sometimes my reasons for a painting may be no more complex than capturing the shape of a cast shadow or recording the silhouette of a young woman against a window. I jot down my ideas in a small notebook I carry with me, and these rough shorthand sketches, together with written notes on color and other points, help me recall my feelings even a long time afterward.

In *Reflections in a Quiet Mood*, I have tried to suggest great depth by leading the eye through a series of frames, beginning with the framed painting itself, moving on to the frame of the mirror and ceiling, through the half-open (yet barred) doorway, past the broken squares of the tables and chairs, to the distant bars of the window and the outside world beyond. The light also enters the house in layers, barely reaching the deep interior where the woman, heavily clothed, sits in silence, shutting out all light and noise. The turban she wears recalls another Vermeer, his *Young Woman with a Turban*.

Reflection in a Quiet Mood, 50″ x 57″ (127 x 145 cm). Artist's collection.

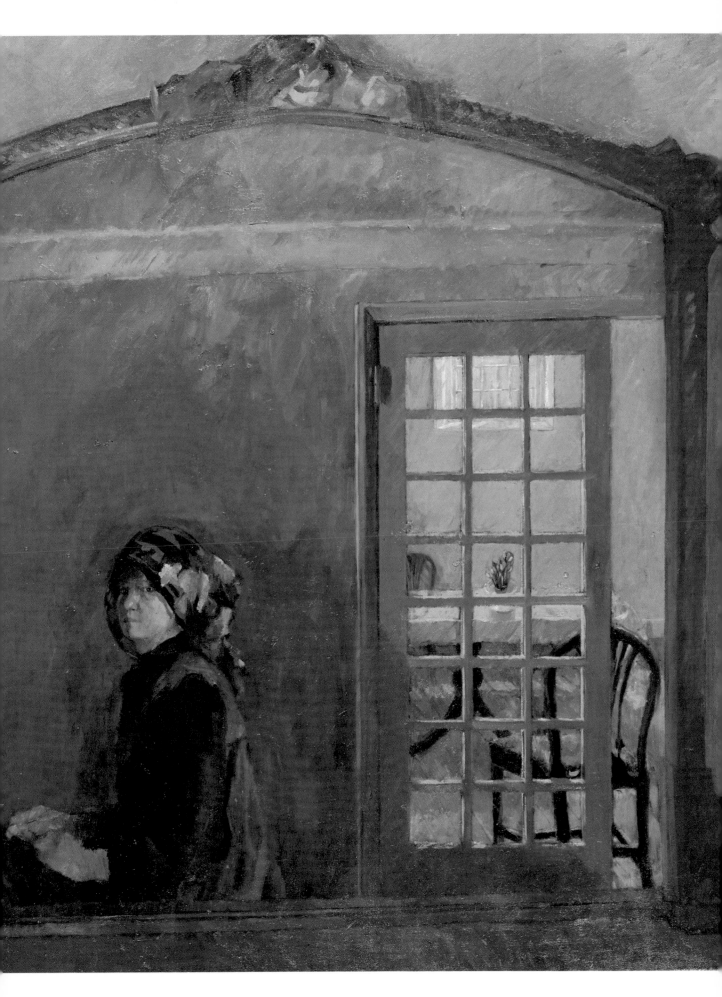

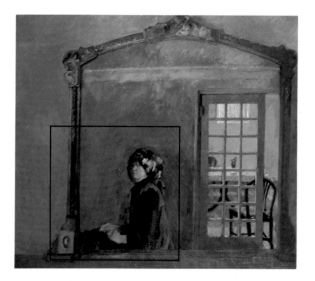

I have used myself as a model for the sake of convenience, but this is not a self-portrait. Rather, it is a strong expression of an interior mood—the interior of a home and the interior of a personality. As in *Malayan Memories*, the colors are essentially subtle blue-grays and oranges, relieved by the soft green-gold frame and bright yellow-white light of the distant window. The main interest is in the gradual shift of values, from the deep tones of the interior to the distant sunlit squares of the barred window. Yet, above all, there is the riveting expression of the face in the mirror that first catches our eye, then calls us back for yet another look.

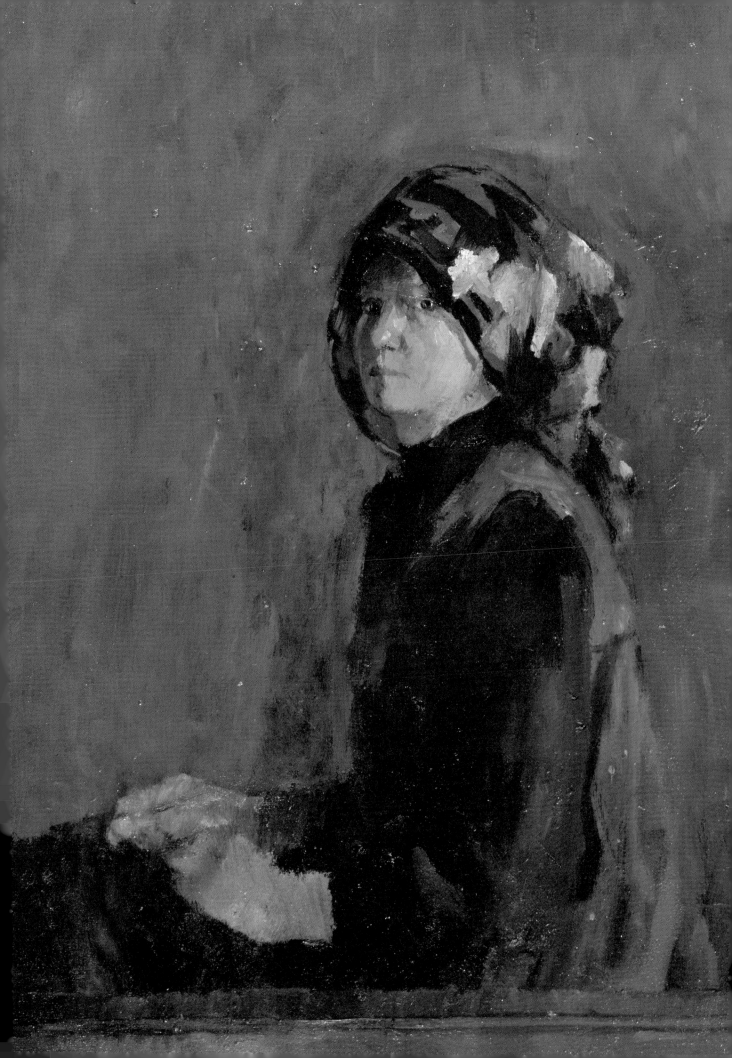

A Bright Mirrored Image and a Shadowed Reality

ETCHING/AQUATINT

I have always enjoyed painting a backlit scene, where the subject is silhouetted against a strong light so that the shadowed body and features are barely distinguishable. Here there also is an interesting interplay between reality and reflections in that we see only a shadowed version of Susannah. The well-lit full face is merely a reflected image.

Another favorite subject is painted here: the effect of warm sunlight on the transparent curtains, seen against the cool, blue-violet pattern of the embroidery and shadows cast by the window-frame. Once again, it is contrasts, the interplay of one theme against another—shapes, colors, temperatures, values, lines, curves, whatever—that establish interest, drama, mood, and the overall tonality of the painting.

Like *Salomé*, a painting that I did at about the same time, *Susannah* has its roots in a biblical story. Susannah was a young woman who was raped, then falsely accused by her attackers as an adultress. She was saved from unjust punishment by Daniel, who confronted two respected elders of the community and trapped them with clever questions. I had always thought of Susannah as rather a naive character and in this painting, she is seen looking at herself in her pregnant condition, months after the rape in the garden, sighing at the hopelessness of her situation. That sigh seems to echo all the way down from the pages of the Apocrypha.

Since the lighting here was of particular importance, and its effects on the figure were subtle, I planned the painting by means of an etching/aquatint. The process—which I will not go into here—basically involves a favorite method of mine, working from light to dark in a series of gradual stages until I have reached the darkest value I want. Etching, like watercolor, is a natural medium for working out a composition because it resembles, in its treatment of values, the glazing process I use in oils. It was particularly useful here because it enabled me to decide how dark I wanted to go in the painting, and helped me resolve the treatment of various patterns in the robe and curtain. After making the etching, I decided to turn her face more toward the window so she is shown full face in the mirror, silhouetting her head and torso less strongly. I also tried to keep the painting simpler and less textured than the etching, aiming for a quieter mood. Once again, as I had done in *Winter Evening* and *Reflection in a Quiet Mood*, I wanted to contrast a silhouetted figure with its mirrored image.

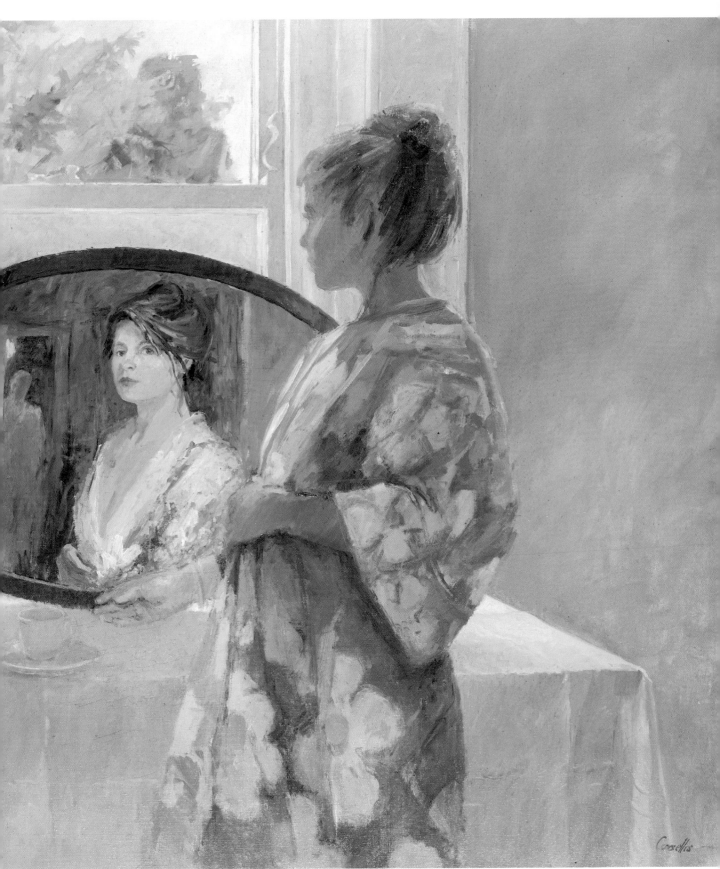

Susannah, 45″ x 50″ (124 x 127 cm). Collection Kenneth C. Slater.

I worked down to the medium-dark shadowed values gradually, rubbing on thin glazes and gradually darkening them so they would not create a strong silhouette that would detract too much attention from the carefully painted face in the mirror. In fact, to ensure that the mirrored face would be of greatest interest, I placed the brightest, deepest color, strongest contrasts, and most careful, and detailed painting there. I also included the shadowy figure of a man, perhaps the one responsible for her condition. On the other hand, I barely suggested the actual details of her shadowed figure, concentrating all the attention on the conflicting emotions in the mirrored face.

The same light blue and violet tones keep repeating against the warm tones of the flesh and light—in the curtain, the robe, the shadowed windowframe, the tablecloth, the shadowed flesh—echoing like a theme and variations. I anchored the face in the hard-edged, dark-framed mirror with strong strokes of cerulean blue and viridian repeated in a lighter variation in the robe and cup. The gentle brownish greens of the outdoors, light and muted enough not to detract from the scene indoors, are also used in the shadowed hair and on the robe.

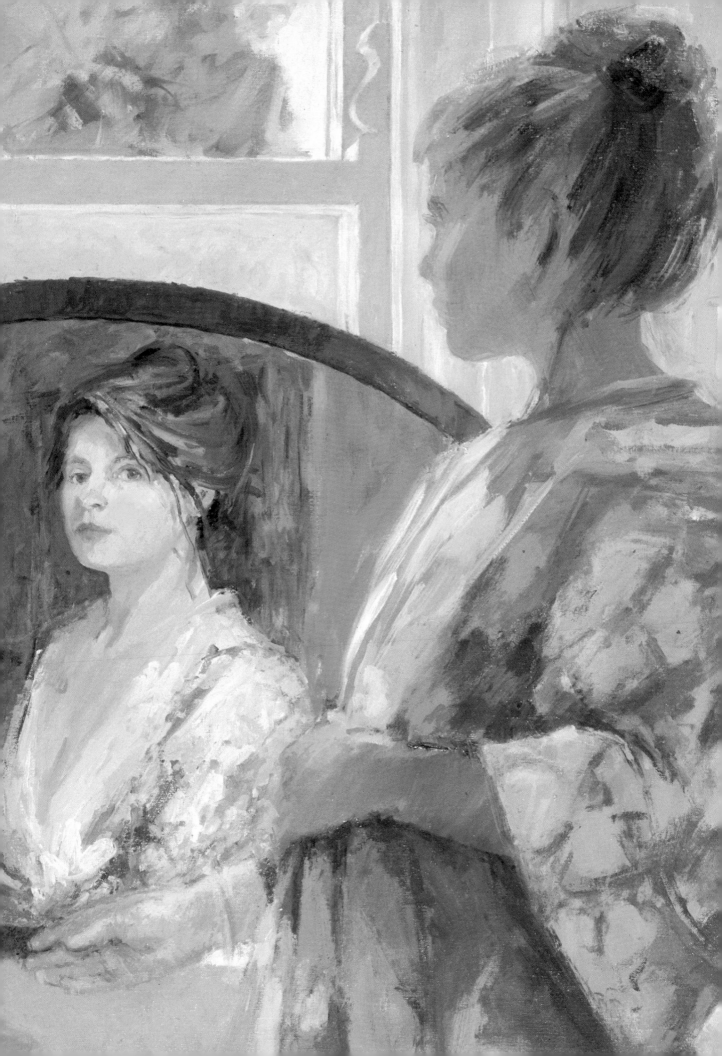

Bright North Light and Deep Space

This painting combines two separate ideas. I had wanted to convey the not-so-glamorous routine of dancers: the hard work, non-stop hours and hours of training, yet still to express their beauty when wearing woolen tights and old leotards.

In addition I wanted to create the effect of deep space and bright, cold light. In fact, I originally began this canvas as a painting of an empty room. Then I came across some of my watercolors of the dancers and arranged them to fit the composition of the empty room—and it clicked.

It was a sunny afternoon in early spring, and despite the fire in the stove, with its three bright spots of orange, the room was large and hard to heat. It faced north and, even with the bright sunshine outside, the only light that penetrated the deep recesses of the almost empty room was the cold light of the sky. Nonetheless, the reflections from the bright building opposite were warm, and the occasional touches of orange and blue enlivened the soft, deep umber tones of the room. The only direct light was the cool light from the window, but the mirror represented a warmer, reflected source of light. While it echoed the outdoor light, it also picked up the deep tones of the room; so there were two different moods in the painting. The carefully painted tones in the ceiling also conveyed a sense of light, depth, and space.

I wanted a severe composition, with the cold, hard lines of the floor, bar, ceiling, window, and stovepipe contrasting with the round shapes of the mirror, sheets, and pools of light on the floor. I planned the diagonals of the distant roof, both dancers' arms, the long dark shadow on the floor, and the overturned chair to create visual interest and draw the eye into the center of the painting.

Rehearsal Room, 40″ x 50″ (102 x 127 cm). Artist's collection.

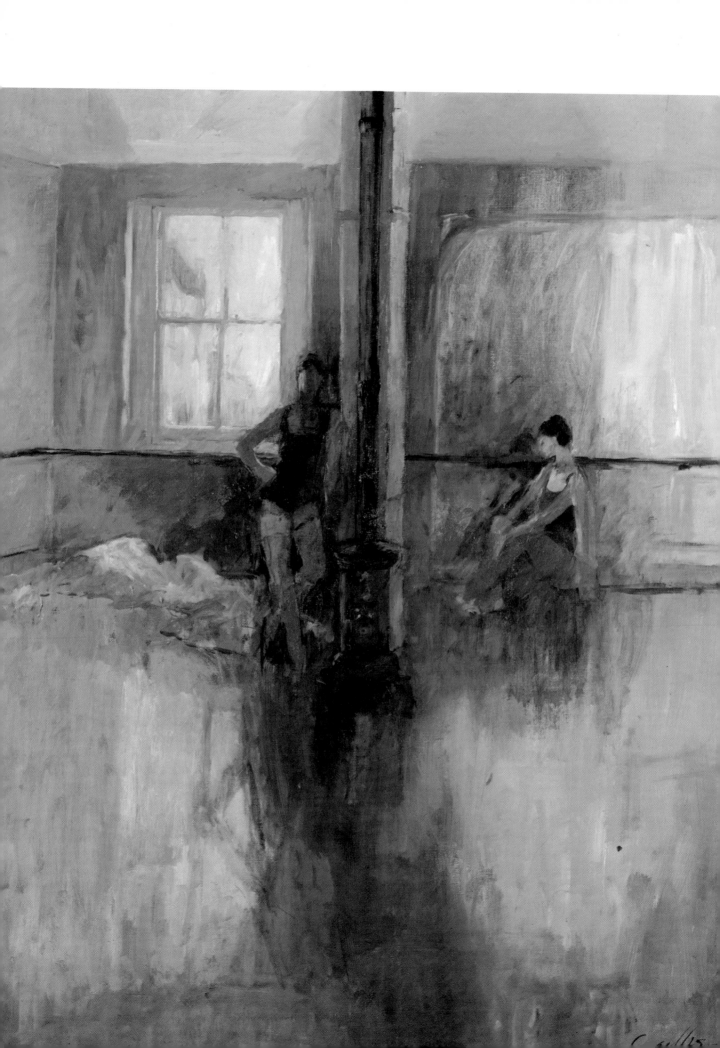

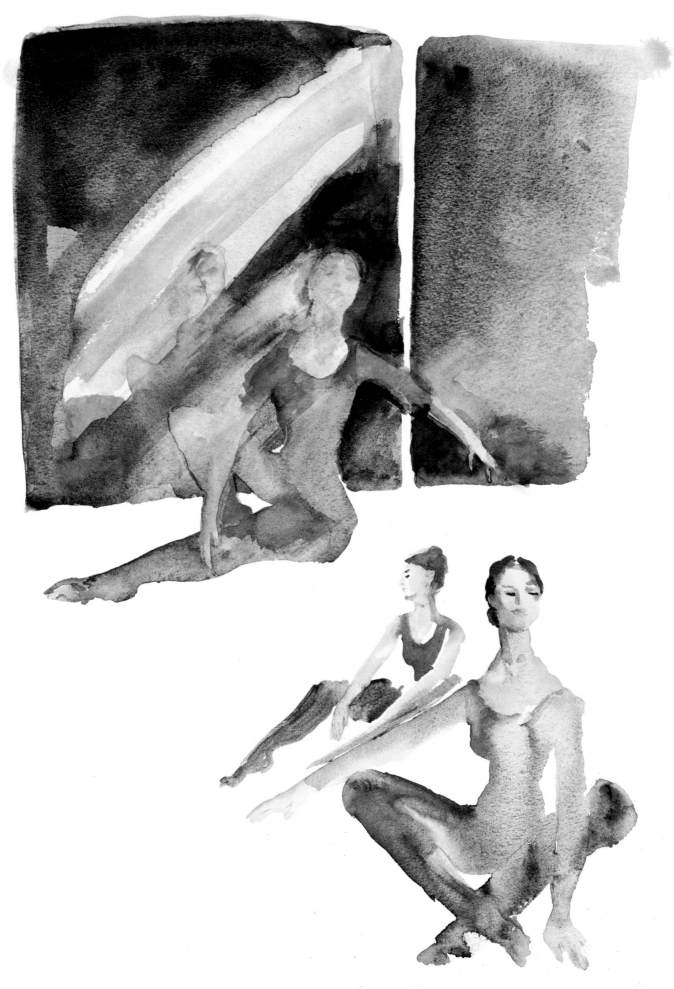

I drew numerous studies of the dancers at the Ballet Rambert in London, and as I watched them, I was struck by the sheer physical effort involved. They would rehearse for hours without stopping, and when they did, they would sit or stand alone, not talking to one another, taking the importance of relaxing as seriously as their dancing. These watercolors were done more as notes to catch a mood or a movement rather than as paintings in themselves. However, working among the dancers gave me a chance to do quick, clothed life drawings. It was a stimulating experience, an opportunity I could later use for a painting.

Watercolor Sketches

The mirror behind the moving dancer in the upper drawing at left created a source of reflected light. I used such a mirror later in the painting; it helped to establish important warm backlighting for the seated dancer. Rays of sunlight were also reflected in the mirror from the window behind me.

In the second watercolor, I found these two dancers' moments of relaxation as fascinating as their actual movements. Both seemed to require intense concentration. The concentrated repose suggested here by the seated dancer in the rear was the inspiration for the seated dancer in my painting. A "happy accident" occurred when I painted the forward dancer. The pigment clumped together, forming a granular residue that emphasized the rounded form of her torso.

The dancer in the watercolor at right assumed this unnatural position, an exercise held for about three seconds. Then he straightened his legs and repeated the knee bend, slowly and without a tremor or shake, with a perfectly controlled movement. The pose was especially beautiful because of the shape his body made against the dark mirror while his legs were outlined against the white wall.

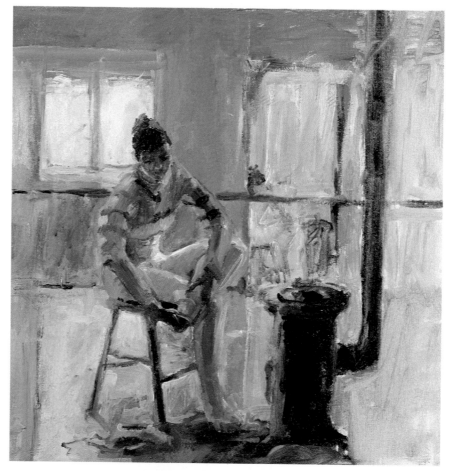

Oil Sketch

The oil study above bears many resemblances to the final painting. The figure was in shadow and a strong light came from the window behind her. The dancers seemed oblivious to the state of the light, but as far as I was concerned, it was getting darker by the minute. I painted rapidly, using rather thick paint, working on canvas taped to board. I tried to establish immediate relationships of shapes and tones first. I blocked in the window, then established the shape of the figure against the window and bar. The hard, vertical lines of the stove provided an appealing contrast to the soft, rounded curves of the dancer.

Leaning wearily against a central column, the standing dancer is in shadow, the cool light of the window behind her. A warm streak of light is reflected from the nearby building onto the plane of her cheek and the upper part of her bent arm, while the rest of her body fades into the darkness of the studio. The mood is one of quiet isolation and fatigue.

The cool green of her stocking was made with mixtures of cerulean blue, viridian, and terre verte. I repeated this color throughout the painting, including on the left-hand wall, where I worked the green in broad, diagonal strokes over a light underpainting of diluted layers of cadmium red and French ultramarine.

The window, of course, is the lightest area in the painting and the warmest, with the sienna tones of the building contrasting with the cool tones within the room. I deliberately kept all values outside the window relatively light, even the distant roof, because I wanted to distinguish outdoor areas from indoor tones. I painted the window frame with a combination of burnt sienna and French ultramarine, and used French ultramarine, viridian, and some cadmium red for the deep shadow below it. Note the interplay of values to the left of the window frame. The light strikes a strip of wall at right angles to the window, creating an unexpected vertical stripe that adds depth and dimension to the area. The ballet bar, which serves as a central unifying band in the painting, is quite dark, even darker than the shadowed area beneath it. It is this constant comparison of values that gives a painting a sense of light. By softening the window bars, creating a haloed effect by almost completely losing their lines at times, the intensity of the light is also suggested.

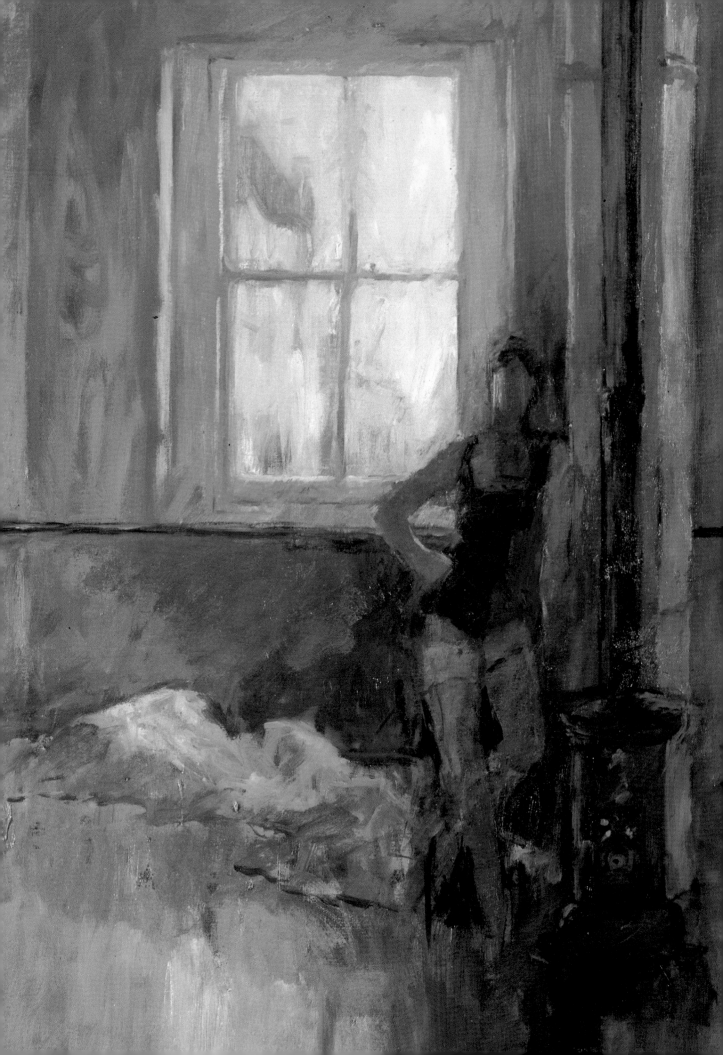

The broad expanse of the floor plays a major role in expressing the mood and colors of the scene. I painted it with vertical strokes to enhance the feeling of depth and space in the room. There is little of the floor that expresses its own local color. Instead, its highly polished surface serves to reflect the light from the window and mirror, as well as to repeat the dark colors in the rest of the room in a series of broad ovals and verticals.

The oval patch on the left (a mixture of cobalt blue, viridian, and white) reflects the cool light from the window. It is separated from the pool of light on the right by the deep French ultramarine / burnt sienna shadow cast by the stove, back wall, and dancer's body. You can even see the reflection of her bent arm there.

The pool of light on the right, a combination of cobalt blue, cadmium red, and white, reflects the light and colors of the room as seen in the mirror. The floor is thus deeper, warmer, and duller than the light area on the left because it mirrors a secondary, reflected light source, not a primary one. Note that I deliberately omitted from the floor many of the colors and values actually present in the room above. Had I repeated them, I would have attracted too much attention to the area and spoiled the composition and color balance of the painting. You can't always paint exactly what you see. You're making a painting, not creating a photographic reproduction of a scene.

The seated dancer was developed from the rough watercolor sketch shown earlier. Facing inward, she brings the eye into the painting and underscores her tense, introspective mood, even though she was relaxing during a rehearsal break. The light from the mirror (a mixture of white, cerulean blue, and burnt sienna) has bathed her chest and shoulders in a warm glow of white, cadmium red, cobalt blue, and burnt sienna. Her hair, a rich, dark burnt umber forms one of the deepest tones in the area. I gently suggested her reflection in the mirror with dark, undefined tones that would not detract from her soft, almost featureless face. The long vertical strokes of the mirror help suggest the high ceilings, and several carefully placed strokes of pure cerulean blue near her bent legs enliven the quiet tones in that shadowed area.

Interiors and Exteriors: A Balanced Tension

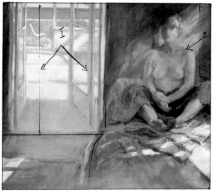

LIGHT SOURCES

This is a painting with disturbingly mixed contrasts, both visual and emotional. It is held together through a severe geometric pattern, with strong contrasts of light and shade, empty areas and active ones, bright areas and dimly lit corners, and a questioning silence: Why is she sitting there, so tense and still? And why is there no sign of another person, no beach towels or any of the other summer vacation belongings? Why has she moved inside—why did she leave the shade of the umbrella on the patio? The scene is almost the same as in *Sunlight and Shadows*, but it is interesting to compare the two paintings because the moods are quite different.

I had always wanted to try a painting with such wide extremes of tone and color temperature, and the chance to do it happened suddenly one summer day. I was at my summer cottage with a friend and her daughter. It became too hot to lie in the sun and so we moved inside where it was cooler. The young girl sat on a bed, half in the shade and half caught in the beams of diffused sunlight from the window on her left, listening to a play on the radio. I was sitting opposite, drawing her, but the light from the porch was so intense that I could barely distinguish her face and body.

There were two sources of direct light: the bright sunlight on the patio that was strongly reflected into the inner room, and the bright sunlight that streamed into the darkness onto the bed and floor from the window on the right. Because of the intensity of the light, there is also a strong reflected light, actually a secondary light source (see diagram).

To paint the scene, I glazed the walls with layers of French ultramarine and burnt sienna, building up veils of uneven color. I enhanced this effect by scrubbing the paint onto the canvas, then wiping off light patches to leave streaks of pale dried paint underneath. This technique was particularly effective on the sunlit wall behind the figure.

I painted the figure with mixtures of cadmium red, rose madder, yellow ochre, and cobalt blue, cerulean blue, and French ultramarine, sometimes adding a touch of terre verte to subdue these hues and make them more subtle. I handled the skirt, hands, and feet more broadly, contrasting them with the more subtle tones in the upper parts of her body. There I worked in thin layers of paint, scrubbed on with a broad, soft brush. I added the fine details with a small nylon brush, turned on its side, to drag and scumble the paint, which gave me the scratchy effect I wanted.

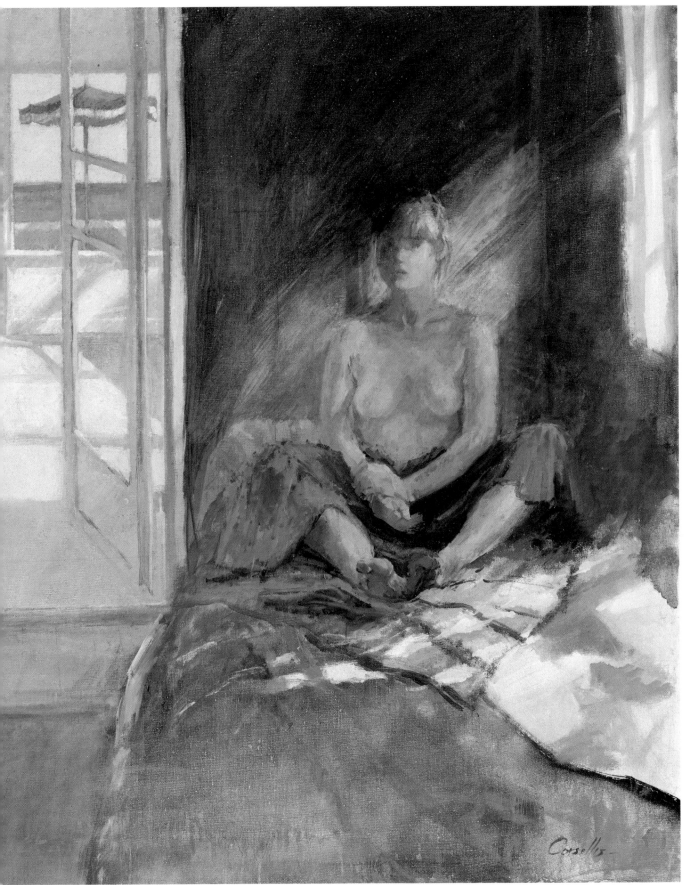

Away from the Sun, 28″ x 32″ (71 x 81 cm). Artist's Collection.

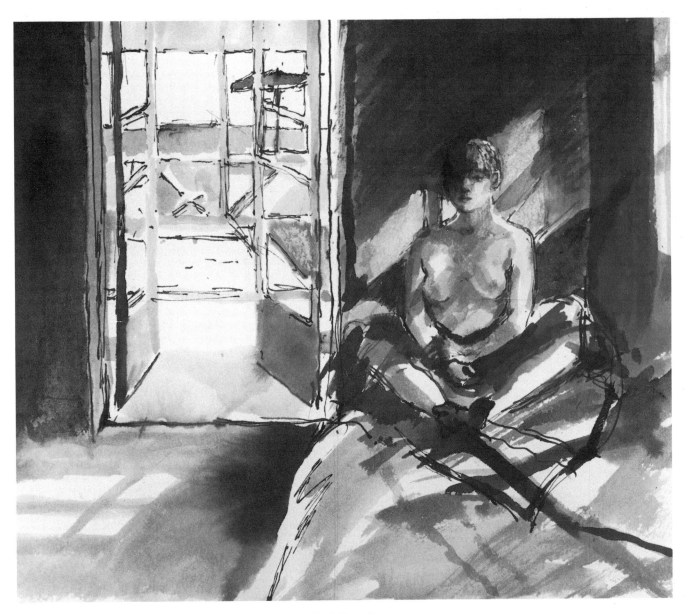

Pen and Ink Wash Drawing

I had started some quick sketches when I noticed by chance that the angle of the shadows and doors created a strong geometric pattern. I made a pen and wash drawing to capture the composition and values I saw.

The scene contained a complexity of shapes and angles. The horizontals of the wall, balcony, and horizon were counteracted by the verticals of the windows. They, in turn, were opposed by the strong diagonals of the beams of light on the figure and the angle of the folded legs. These lines often formed triangular shapes that required great care in handling, for they acted like arrows, directing the eye's attention to the figure and eventually to the distant sea.

The small tracing here shows the pattern created by the diagonal light and its bounced reflections; the many stiff horizontals and verticals of the rooms; the diagonals of the opened doors, striped blanket and towel, and the patch of sun-

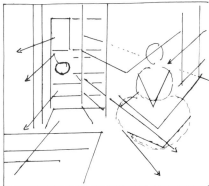

COMPOSITION

light on the floor; and the soft circles of the girl's body and the shape of the distant chair. There are also a series of crosses: the splash of light on the floor on the left, the window frame on the right, and the line created by the beams of light crossing the stripes on the bed. Her arms and legs are also crossed. I adjusted the angle of her right leg so it continued the line of the white towel on the bed and led the eye to the shadow on the patio.

The doors were made of steel and glass, both hard, mechanical materials that increased the sense of severity. I added a round table to help break up the straight lines of the composition, but it didn't work, so I omitted it from the final painting. After I had completed the painting, I realized that this highly structured composition allowed me to experiment with wide extremes of tone and color temperature because it kept me in control of the painting.

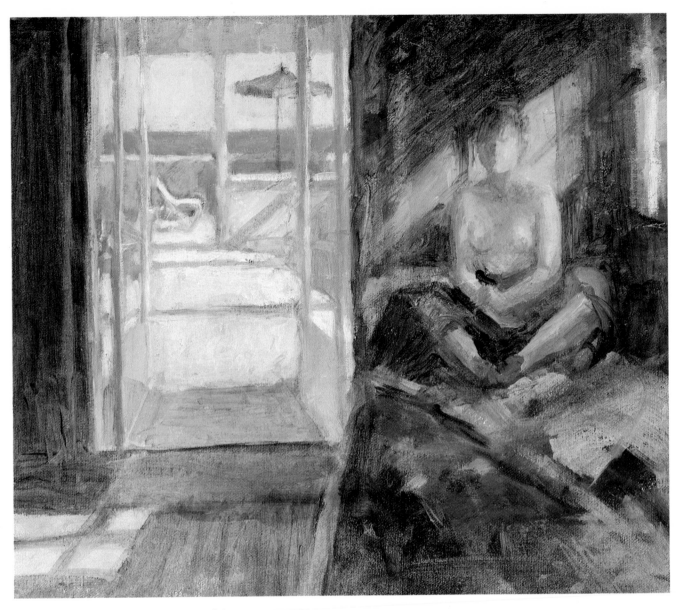

Early Stage

I began the painting by blocking in the main shapes and values. The major value contrasts were between the bright light outdoors and the dark interior, with the head and body of the girl spotlighted in a ray of light and held motionless against the dark wall.

I painted the figure with subtle, interesting tones but created dramatic, abrupt, changes of tone elsewhere. For example, the door jamb signaled a quick change from light to dark, as did the window frame's cross-like shadow on the floor and the white towel on the bed. Although there were subtle tonal changes in the shadows on the balcony, the softest and most gentle gradations are still on her body and in the light on the wall directly behind her.

At this stage, her upper torso was quite close in value and color to the sunlit wall behind her. On the other hand, her blue skirt was dark, making the tone of her body appear even lighter in contrast. The white towel on the bed was lightened considerably in the final painting.

I realized that, apart from the contrasts within the geometric composition and the counterpoint in tones, there was also the contrast of the hard metal doors against the soft curves of the flesh. I decided that this would best be resolved by the careful opposition of warm and cool colors.

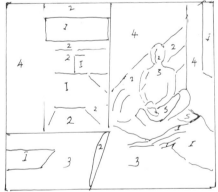

VALUES

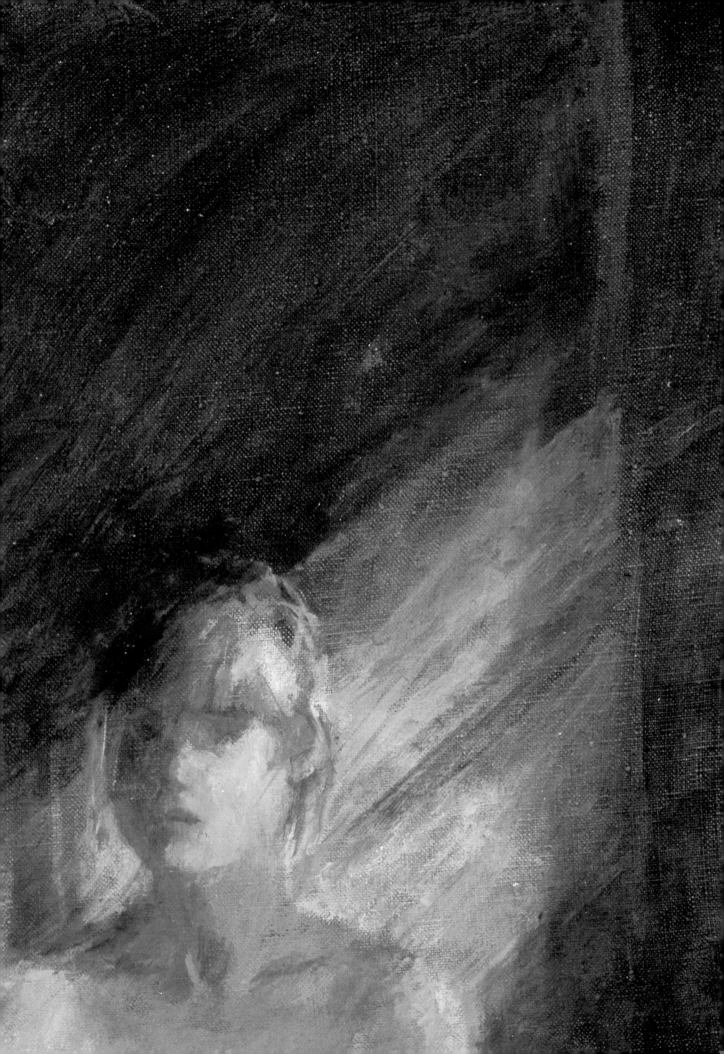

The dramatic contrasts of tone and color temperatures that characterize this painting as a whole are clearly seen in this detail of the head and window. To suggest the intense heat and light of the summer day, I rubbed out areas of the underpainting just to the left of the window, creating a halo of light in the shadows, and left the windowpanes almost white to imply the bright glare there. The sun was so strong, in fact, that I painted it almost neutral in intensity, giving it a bleached-out quality that contrasted with the warm shadowed wall next to the window. But as the light entered the room and was surrounded by these warm darks and bright fleshtones, it picked up the warm tones of the flesh, almost melting the edges of the figure against the wall behind her.

I deliberately left her features understated because the painting was concerned with mood and light—it was not a portrait. But there was a certain tension in her expression. I painted the shadows on her head and body in thin warm and cool glazes, reserving touches of opaque sunlit tones for the lighter areas.

The wall on the right is quite warm, but farther from the window the area above and behind her picks up the colors of her skirt and the violet tones of the shadowed areas on the patio. These color transitions are important; they help to move our eye around the painting as much as the more obvious geometrical lines do.

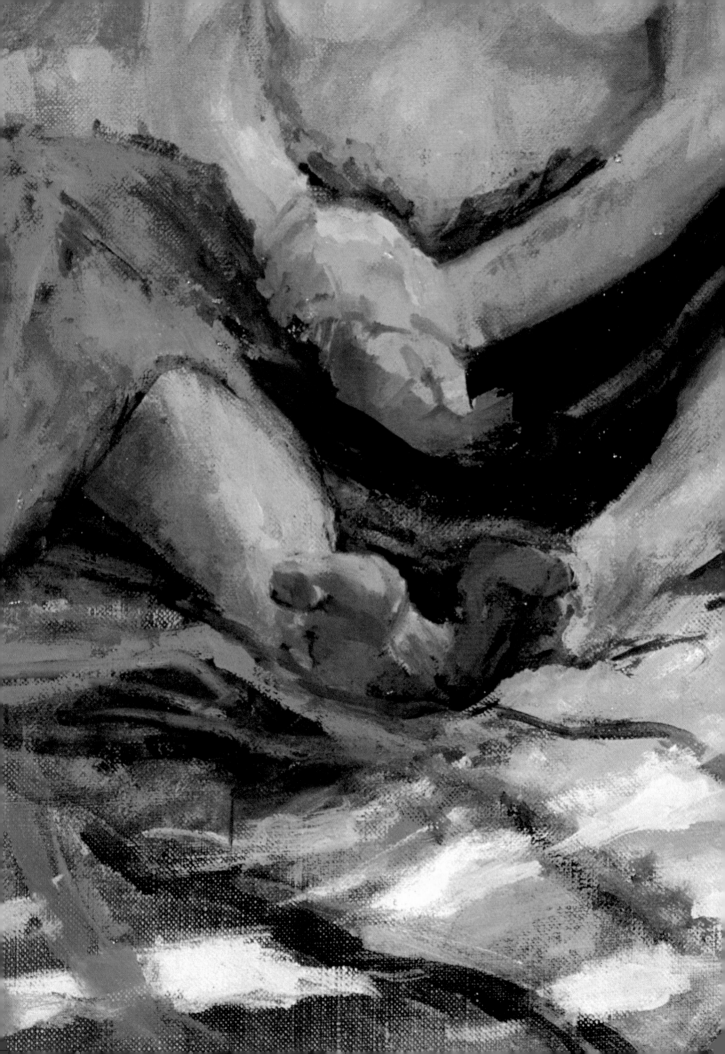

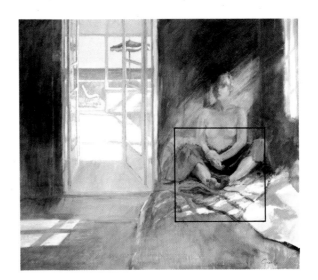

Most of the light on the body was filtered through wet towels and other beach clothes that hung on the line outside the window. This gentle, diffused illumination created a range of warm and cool colors over her body. I arranged these so that her legs were cool, her arms warm, her abdomen and breast cool, and her neck and upper chest warm. These changes in color temperature were extremely subtle, for the coolest color on her body still had to be warmer than every other cool hue in the painting.

I mixed the cool colors from French ultramarine, rose madder, white, terre verte, and burnt sienna. For the warm colors, I used cadmium red, burnt sienna, yellow ochre, and white. By creating these changes in tone and temperature, her body itself almost became the subject of the painting.

I also varied the texture on her body by contrasting thick and thin paint and wide and fine brushwork. The overall warm flesh tones were offset by her blue skirt. At first, I painted it a dull gray, but it lacked vibrancy and was too close in tone to nearby features, so I changed it to blue, and as soon as I did that, her flesh-tones became more alive. I also added a touch of lighter blue to the skirt at her left kneecap and to the area nearest the balcony. These two light patches picked up the light from each window and helped relate the figure to the bright light outside. Her blue skirt also contrasted with the glow of her sunburned arms and hands. The two orange stripes on the left (see full painting) intensified the blues in the area.

The scene outside was stark both in its strict geometry and bleached, high-key colors. I painted the doors carefully, relating their vertical and diagonal lines to the background horizontals. I studied the negative shapes carefully too, as you can see in the small watercolor study. The study also shows how I worked out the color scheme (French ultramarine, burnt sienna, and viridian) and the complicated breakdown of patterns and shapes there.

Lost-and-found light and dark lines, such as the puttied edge of the doors where glass met steel or the shadows of the distant ledge and the sunlit ledge below it were carefully observed and recorded, adding both depth and interest to the finished painting.

While I painted the dark interior walls with thin glazes, I used thicker and more opaque paint for the stark, bleached light outdoors. The sun was so bright that it was almost white in its intensity, bleaching out all color from areas on which it fell. On the other hand, the cast shadows on the patio contained a great deal of bright color, though the tones were high in key. The stone wall was a gentle burnt sienna, the blue water shifted from viridian to French ultramarine at the horizon, the light blue sky was almost white, and the shadows on the patio ranged from blue-violet to yellow-violet.

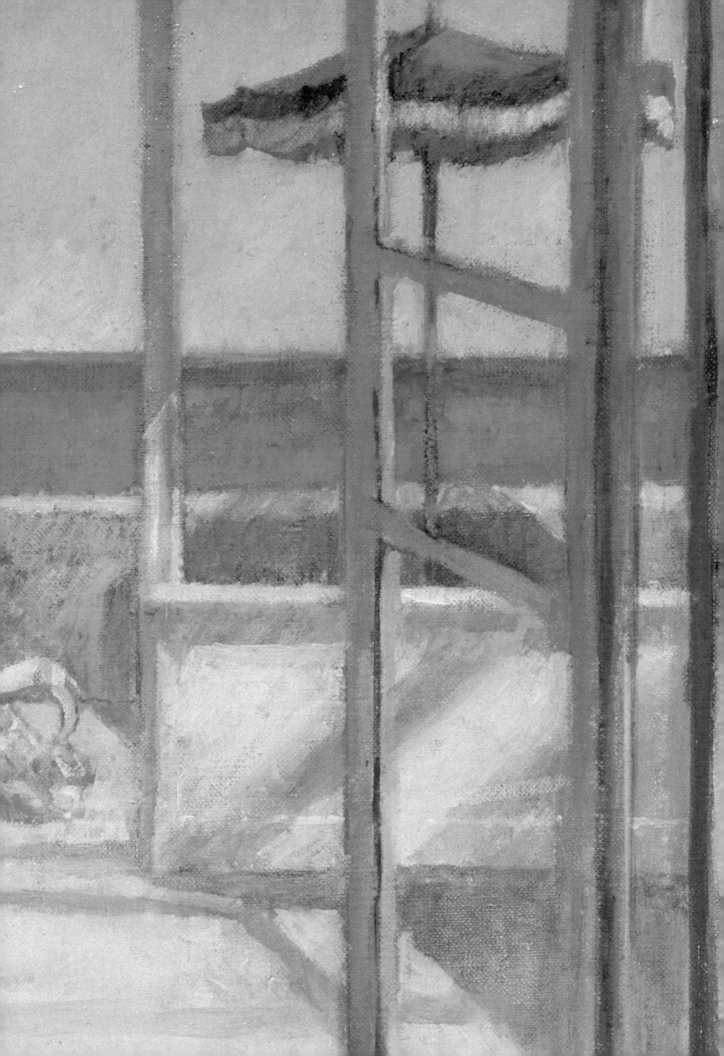

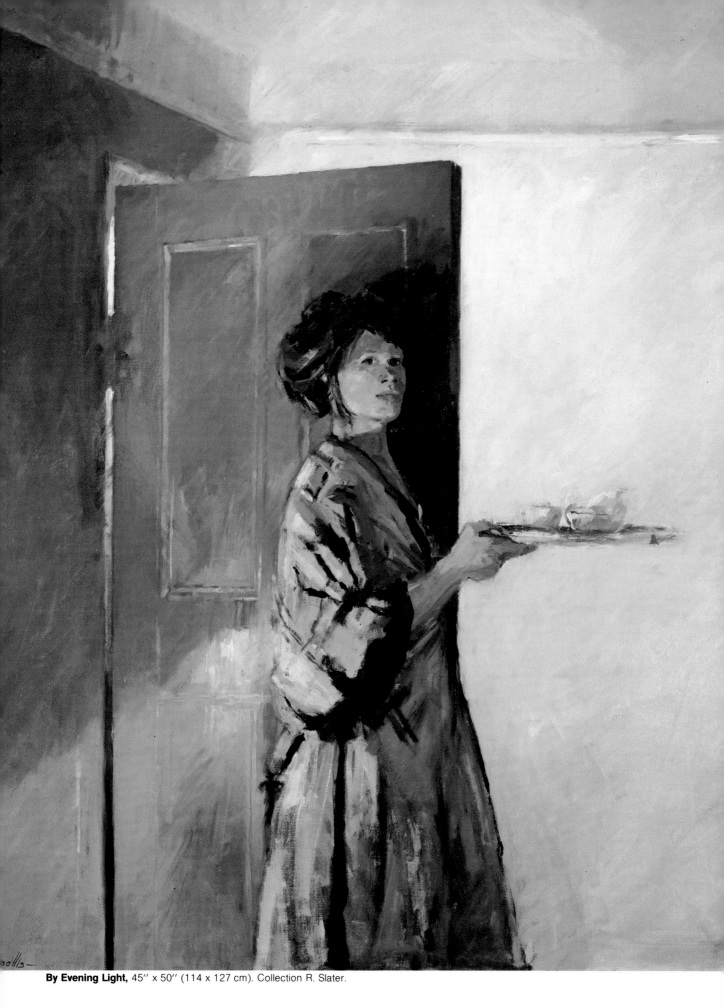

By Evening Light, 45″ x 50″ (114 x 127 cm). Collection R. Slater.

Dramatic Night Light

One winter, lying in bed with the flu, I began to notice the interesting changes of light on the bedroom wall. I had been thinking of painting a series of "Women at Night" paintings, but had no definite plan. Suddenly an idea took shape. There was a strong, bright light on the stairway behind the bedroom door that lit up the bedroom wall and ceiling. A second light by my bed cast a strong diagonal streak on the open door. But I still needed a subject.

Then one evening, standing at the door, a tray in my hands, I was startled by the effect of my image in the mirror against the backdrop of lights and shadows in the room. The entire blue-gray composition was brought to life by the warm tones of my face. Although I often modify and rework my paintings, this one flowed easily. Using myself as the model and working without hesitation or major change, I painted it in only a few days.

The face was lit from below, and the low-angled lighting cast an unusual shadow on the neck and around the eyes. Although the effect could have been a mysterious one given the right subject matter (as in *An Evening at Betty Mundy's*), here it merely heightens the drama of the moment.

The light from the landing reflected onto the bedroom wall and ceiling and warm tones contrasted with cool ones in a most exciting way. I wanted this painting to be a pattern of cold darks and warm lights, and kept this desire in the back of my mind as I painted what I saw, lightening some passages and darkening others as I went along, until a satisfactory balance was achieved.

The coldest dark was directly between the warm-toned face and the bright light on the wall. The soft light on the wall and ceiling encircled the figure in its warmth. I scumbled light opaque tints of cerulean blue and yellow ochre heavily mixed with white, over thin, transparent strokes of burnt sienna, yellow ochre, and terre verte on the right. Then, to keep the eye within the painting, I deepened the corners of the room with soft tones of cadmium red, cobalt blue, and white, scumbled over burnt umber and grayed with cadmium yellow pale. I repeated these mixtures in a deeper value on the door and shadowed wall beyond it.

The lighted area behind the dress contains greenish tones of terre verte, burnt sienna, and French ultramarine. The warm light of the bedroom lamp shining on the door was painted with mixtures of cadmium red, yellow ochre, white, and some cobalt blue. I cooled the gown with terre verte, a gentle color without much covering power that subdues a tone without changing its color much. The cold darks—such as the shadow cast by the head on the door—were a mixture of French ultramarine and burnt sienna. To draw the eye to important areas such as the vertical line of the door above the head, the fingers on the tray, and the body with its striped dress, I used sharp edges and strong value contrasts.

The drama of this strongly lit subject lies in its exciting interplay of dark patterns against light shapes, bright lighting against dimmer, secondary sources of light, cool lights against warm darks, anchoring horizontals at the top and verticals on the left against strong diagonals, and areas of intense activity and strong value contrasts against large areas of comparative quiet with subtle changes of hue and intensity.

The vertical figure, with its striking dressing gown of black stripes (see compositional diagram), is anchored by the sharp, dark edge of the door and held within the circle of light by a strong series of horizontals on top (the molding) and verticals (the doorway and bright crack of light behind her). The brightest light in the painting, from the stairwell, shines through the dark cracks behind the door, leading the eye to the darkest area just below it and to the other light source, a bedside light on a small table just outside the painting, at the lower left. This lamp cast a strong diagonal light on the door and lit up the back and sleeve of the dressing gown. I liked its low angle and the unusual shadows it cast on the face, neck, and around the eyes. I also think the light of the bedroom lamp balances the painting by introducing a set of middle-value relationships that are directed toward the figure, thereby leading the eye into the painting.

The striped dressing gown created an interesting and complex series of movements and shapes that contrasted with the severe lines of the door and the flatness of the wall. Where the tones of the gown were too similar to those of the door, I lightened the lower half of the gown and deepened the shadow there slightly to make the form more apparent.

COMPOSITION

LIGHT SOURCES

VALUES

Despite the intense contrast of the overall pattern of darks on the left against the light wall on the right, the eye eventually returns to the head because that, after all, is the most interesting area.

Playing warms against cools, as I have done throughout, I contrast the warmest, pinkest tones of the painting—the face—against the coldest, darkest shadow there, the door at the right of the head. Although it is difficult to pinpoint the actual colors I used in the face, I would say that the warm colors in the light were made with cadmium red, yellow ochre, white, and terre verte, with perhaps some cobalt blue. (As you can see, it is never a pure color out of the tube, but always a mixture.) The cool shadows on the face, on the other hand, were probably a mixture of rose madder genuine, French ultramarine or cobalt blue (I sometimes use cerulean, too), possibly softened or neutralized with a bit of terre verte, a color that tends to take the harshness out of a purple shadow.

Notice that my brushstrokes follow the contours and planes of the face. This tends to build up and suggest three-dimensional form, the anatomical structure of the head. Although I am subconsciously aware of the overall mood of the model and scene on a conscious level, I rarely think about duplicating the actual expression. Instead, I simply try to capture the general facial forms. The deeper emotions, expression, or character (call it what you will) of the model that I sense are registered unconsciously as I paint.

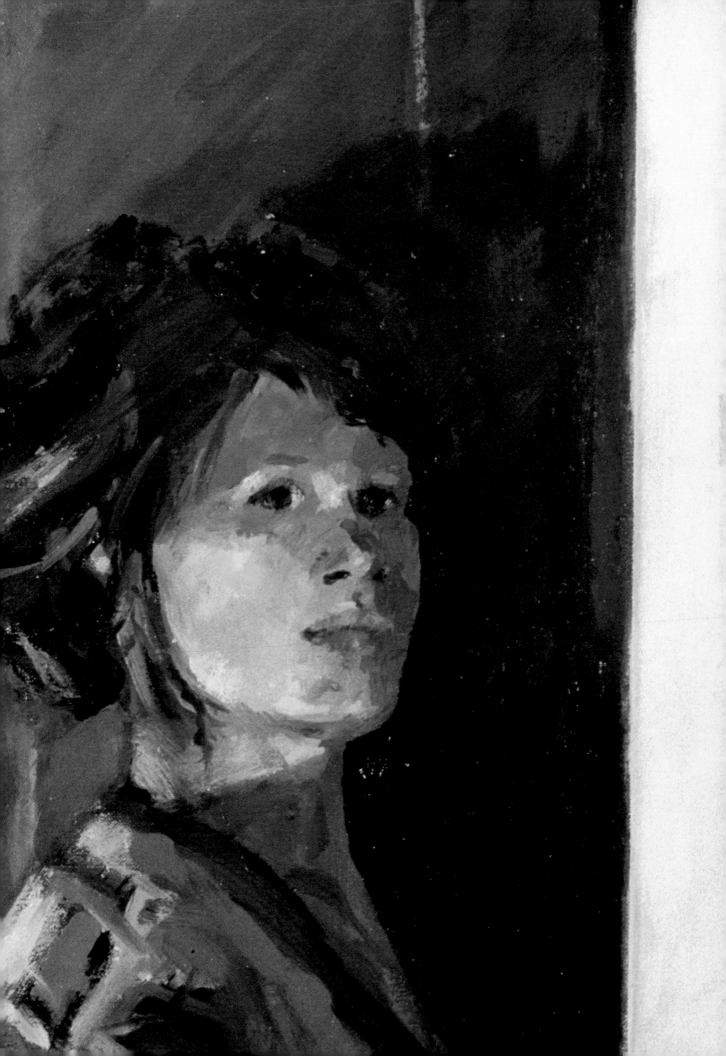

Mysterious Night Light

The idea for my second "Woman at Night" painting came while visiting friends at a remote cottage in Hampshire, England, once reportedly owned by a femme fatale called Betty Mundy. There, it seems, she had lured many a British sailor to his death. The eerie reputation of the cottage was intensified at night by the fact that the only light came from oil lamps and candles—there was no electricity. This, coupled with the baying, hooting, and other nighttime woodland sounds, was the atmosphere I hoped to convey in a painting.

I particularly like painting interiors involving several rooms. After some thought, I decided to place myself in the front room, looking into the kitchen where my friend was cooking. It was winter and the oil lamp on the table cast warm shadows on the walls and floor—more purple than green—and strange reflections on the door. I wanted to keep this interior dark and mysterious and so made the preliminary drawings by oil light in the evening.

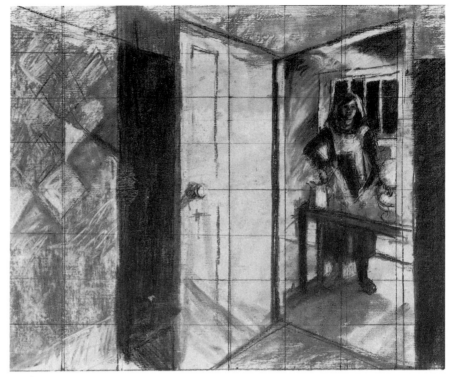

Charcoal Drawing

I had already decided to paint *Betty Mundy* on a 48" x 60" canvas, but working on a canvas that size at the cottage was out of the question. So, having done the series of drawings and watercolors there, I finished the painting later in my studio in London. Here I used sized paper and worked with charcoal, charcoal pencil, Conté crayon, and white chalk, smudging the drawing with my fingers and lifting out the light areas with kneaded eraser. I had originally intended to wash color over this drawing, but had gone too far to do this—even though the drawing still has a certain "gauchness" because it was intended as a plan for a painting, not a finished drawing. As I worked on the drawing, I kept the proportions of my canvas, and its subsequent divisions, in mind, thinking in terms of the golden section. The golden section, a classic means of dividing an area, dates back to the ancient Greeks. It is basically a "perfect" proportion of one line to another, a ratio of roughly 1 to 1.6 or 8 to 13. You can see that I placed the head against the window in that proportion, and located the door within the wall at that point. The horizontal line of the table within the doorway is also at that approximate vertical level—I rarely use ruler and compass but rely on my eye and intuition. I also used these proportions elsewhere—*Sunlight and Shadows, Away from the Sun, Wintery Evening*, and *Morning* are some of the paintings that come to mind. (I later drew a grid over the drawing when I transferred it to canvas.)

Watercolor Sketches

I was primarily interested in capturing the sensations that I felt when I looked at the wall hanging. I also wanted to remember certain details of the setting—the shadow behind the door and its effect on the hanging, the wooden framework of the door (though I later replaced it with my bedroom door), and the position of the light and the way it cast shadows on the surrounding area. I painted a second watercolor that pictured Betty Mundy entering the room from the side, her profile framed in the doorway, but later changed my mind because the overall effect was not strong enough.

It's always difficult to talk in retrospect about a painting because, even now, there are changes I would like to make. But I always have to leave a painting alone at some point because if I were to make it a little bit lighter here and a little bit darker there, before long it would be a different painting. To show you how I work, I have repainted my interpretations of Stages 1 and 2 so that you can follow my procedure.

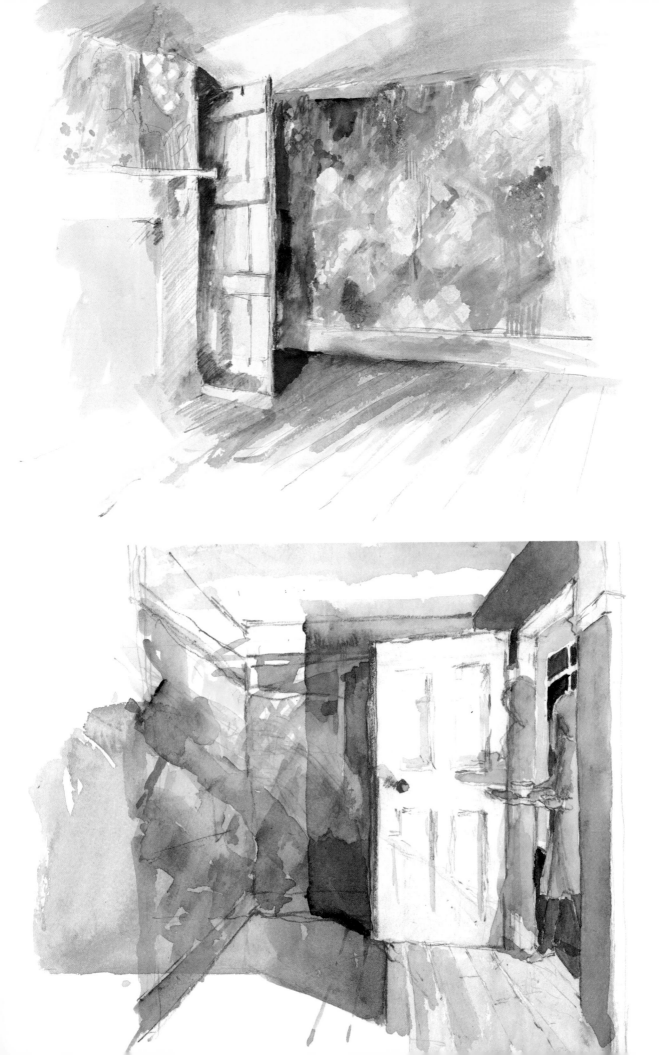

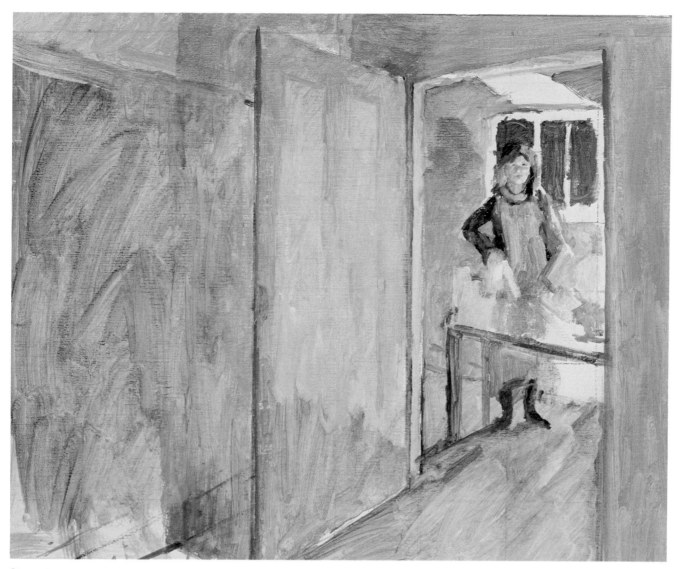

Stage 1

After I squared up the canvas and transferred the proportions and major compositional lines of my charcoal drawing to the canvas, I began by blocking in the warm and cool areas of the painting, starting with the walls and door. Because the tone behind the door was warm, I introduced cobalt violet (a color I rarely use), scrubbing it in with a rag. (Here I made a purple behind the door with rose madder and ultramarine blue). The warmth makes the shadow come forward. Then I painted the door ultramarine blue, rubbing it lighter where the glare of the oil lamp strikes the door. The tones on the far wall range from cool near the table to warm in the shadows. The white streak of the ceiling seemed to exist as a major tone, though it was far too strong and I would have to tone it down later. The rose madder-colored cloth on the table is an important touch, linking the kitchen with the violets of the wall hanging in the other room. I also painted the curved oil lamp and altered the bars of the window slightly from the charcoal drawing.

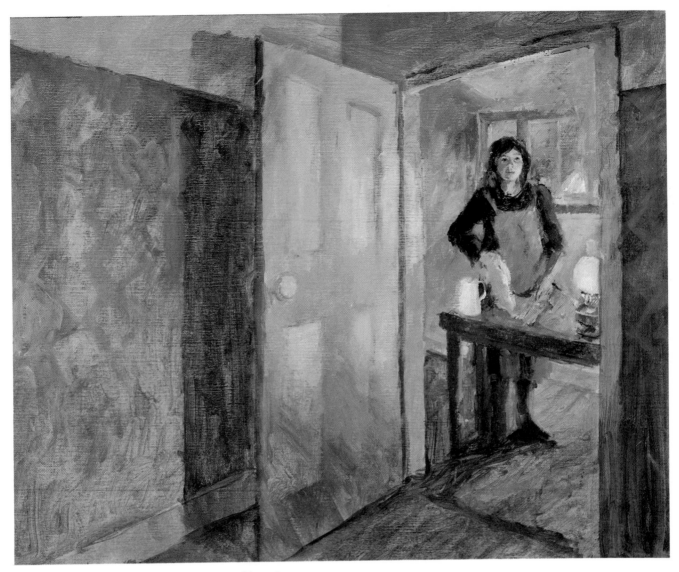

Stage 2

I deliberately patterned the left-hand wall with a wall hanging because it would not have balanced the figure in the next room properly as a solid color. But I knew that I would have to suggest its pattern rather than paint it meticulously so as not to detract from the figure. I resolved the problem by accentuating the diamond shapes in the wall hanging and echoing them elsewhere—in the crook of her arm, the overall shape of her figure, the lines shapes made by the door and wall againt the floor and ceiling, and in the far room

cast by the oil lamp on the walls and in the window. This created a rhythm that integrated the painting into a whole. I darkened the strip of wall over the doorway and on the right, and painted the objects on the kitchen table. I also scumbled the floorboards in with a warm burnt umber and lightened the windowpanes, adding the lamp's reflection. The lighter color threw the head in relief and since I liked that effect, I decided to strengthen it in the final painting.

Finished Painting

There were still several changes I wanted to make, and I had yet to refine the subtle relationships of color and line. For example, I decided to move the oil lamp out of the painting completely and instead show only its light on the far wall and the cool patch of color it cast on the floor. I also changed the face, making it darker, greener, and lower in tone—and I darkened the object in her hand so it was less apparent. The pitcher on the left echoes her shape in reverse, as does a second pitcher I added in place of the lamp. The vertical lines are continued in the reflections of the figure in the polished table. Even though there's a lot of blue here, the umber shadows and violet wall hanging make the painting seem much warmer. If you compare the finished painting and the selected details on pages 110 and 111 with the preliminary studies and the re-enacted painting stages, you will notice many other such refinements.

An Evening at Betty Mundy's,
48″ x 60″ (122 x 152 cm).
Collection Kenneth C. Slater.

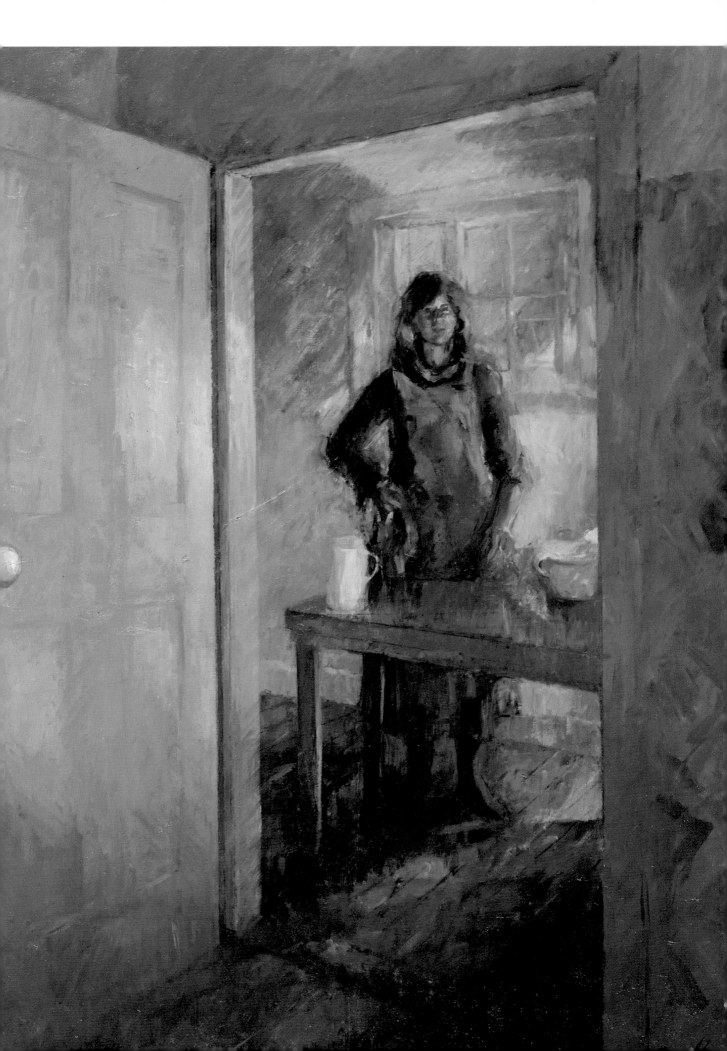

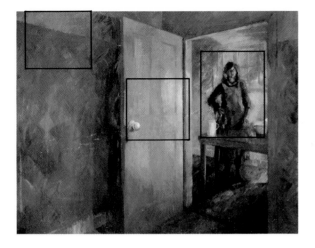

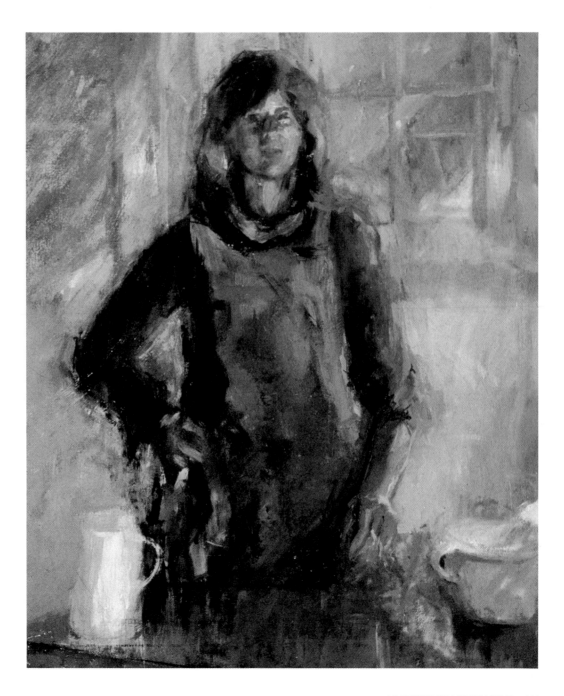

Redefining a Lost Theme

My studio is a long, low room at the top of my house, level with the neighbor's rooftops, with two large windows that face south. One day the sun was shining through some beautiful Japanese reed blinds, casting spikey-leaf shadows from the bamboo plant on the balcony, while my model was posing, just lying flat on the studio bed. It is a fantastic moment—when a scene takes shape exactly as you want to paint it—and I felt a real excitement, almost afraid to breathe for fear the moment would vanish. I hate to use the word "inspired"—people talk about artists being inspired as if some divine intervention were involved—but what I mean is that, at that moment I saw, to my mind, a perfect set of relationships.

I like to involve a figure with its surroundings, creating an intimate network of patterns and tones, and at that moment the horizontal lines of the blind contrasted with the round shape of the bedclothes; the warm patches of sunlight on her body played against the cool shadows; the strong, dark column of the wall was solid against the light rectangle of the window; and the diamond pattern of the balcony trellis was echoed in the sharp angles of the bamboo leaves and the unusual bend of her body. Her breasts and arms also repeated the shapes of the bedding, and the shape of the coverlet repeated the shape of her hair. I paid particular attention to lost-and-found edges, noting that sometimes (as on the breasts) the soft fleshy tones melted into one another, while at other times (in the accents under her arms and between her legs) the edges were sharp and linear. These variations were not of my own invention. When I paint the figure, I paint what I see, the anatomy that the light reveals. In this case, the shadows were there just as I painted them.

Charcoal Drawing

I began with a preliminary drawing in charcoal, just a rough plotting of the light and shade to work out the basic compositional relationships. When I work in charcoal, I always work down to my darkest values, starting with the lightest tones and gradually darkening them until I reach the right value. I also use a kneaded eraser, not to erase, but to lift out light areas by pressing a clean section of it against the drawing. In other words, I'm not rubbing out, I'm rubbing in—rubbing charcoal into the darks and lifting it out in the lights. After making the drawing, I felt ready to work on a large canvas, and I started the painting with great enthusiasm. But I was too confident—I should have known better.

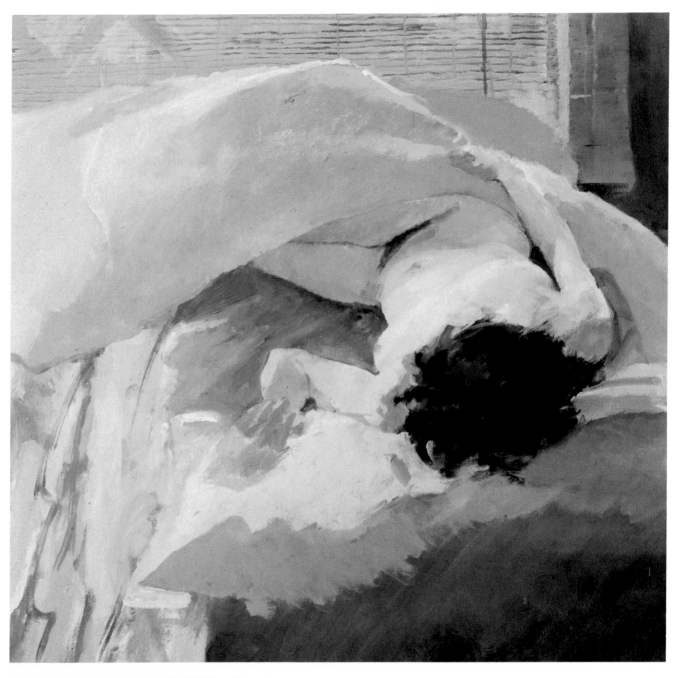

Stage 1

I began the painting with a pale wash of cobalt blue and burnt sienna, laid in with a 1½″ (38mm) housepainter's brush. Then I worked progressively darker, leaving some areas white and blocking in the darkest tones with a mixture of French ultramarine blue and burnt sienna. I always prefer to work up to the darks rather than paint them immediately because it gives the painting a greater sensitivity. I also do this with pencil and charcoal because I find that, in the long run, this controlled discipline works best for me. Although starting dark and rubbing out the paler tones does create a certain interest and excitement, the results are less subtle. As I build the values, I am constantly looking for unexpected shapes I can develop.

Even at this early stage, things were beginning to go wrong. I had made the figure and the bedding too pink (I used too much rose madder)—and had repeated the color in the window area. Also, the shape of the bedding was all wrong. It was too heavy on the left and too high—it looked more like a leaden cocoon than a light, feather-filled coverlet. The window area wasn't working well either. I had detailed the horizontal reeds of the Japanese blinds too precisely, painting individual reeds, and now they were too linear and prominent. Also, the blue underpainting beneath the blinds was too dark and the horizontal line of the porch wall was too hard. The only area that pleased me was the model—I was freer with the figure because I knew the model's time was limited.

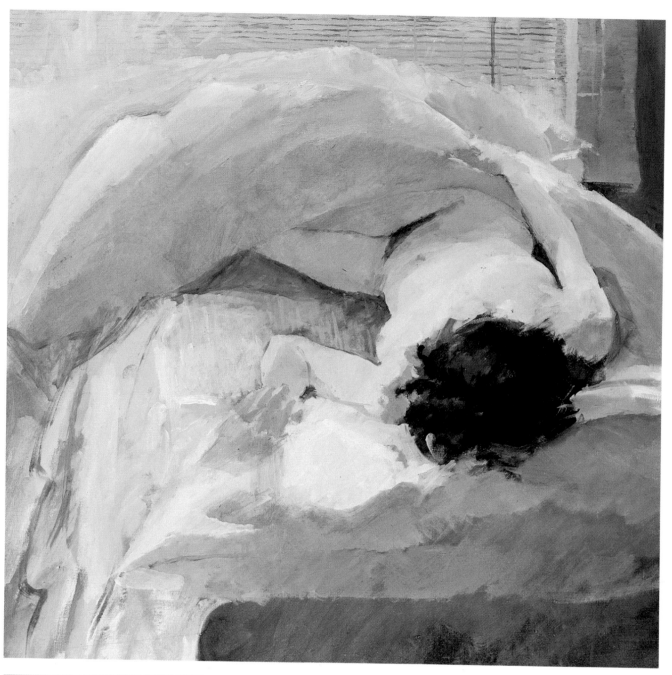

Stage 2

I knew something was wrong with the shape of the bedding and tried to correct it by repainting the upper edge. I tried to weight it down on the left by deepening the shadows there to a purple (French ultramarine and rose madder), but that made matters worse, accentuating the pink tones I wanted to get rid of. By now I realized that the blind was too linear, and so I broke up the lines by scrubbing a warm, light beige (of cadmium orange, cerulean blue, and white) into it, and I lightened the background outdoor tones

too. But in the process, I lost the diamond shape of the plant and trellis and destroyed the original feeling I had captured in the charcoal drawing. My initial enthusiasm had also disappeared. I knew something was wrong, but I couldn't decide what it was because so far none of the changes I had made had helped. In fact, they had made matters worse. In despair, I turned the painting to the wall and tried to forget it, hoping a solution would present itself eventually. And a few weeks later it did.

Oil Sketch

I decided to work out the painting problems on a small canvas to see where I had gone wrong. This time I worked quickly and decisively, carefully placing patches of warm color against cool. It was a bit loose, but it was far more alive and vigorous than the larger painting. I also referred to the charcoal drawing I had made, and that early study showed me how I had lost sight in the larger painting of the contrasts that had first caught my attention—the bright square of the window and lower square of the bed against the perpendicular intersecting darks of the wall and windowsill. I had also forgotten about the diamond shapes of the trellis and plant leaves and the way they echoed the odd angles of her arms and hips.

In Stage 2, the darks on the right were unbalanced and the painting was floating on the left. It needed to be anchored by continuing the horizontal of the windowsill and lower wall on the left. Also, the weight of her body had to be balanced by the strong colors and shapes of the plants and trellis. I also realized that because the room was brightly lit, it was filled with strong reflected lights—and I had made the foreground mattress area much too dark.

I finally realized that the problem occurred because I had ceased to see the painting as a whole and, by concentrating on isolated, unrelated sections, I had failed both to capture the feeling of the sun-filled atmosphere and had lost the compositional balance and geometrical interest of the painting. I became enthusiastic for the larger painting again, and I think this enthusiasm and the confidence it created shows in the final stage.

Finished Painting

The model returned and posed again and all seemed to go right this time, though there were a lot of changes to be made from Stage 2, and I worked patiently on it for hours and hours to get it just right. I lightened the shadows at the base of the bed and under the coverlet and on the legs by increasing the amount of reflected light there. I also deepened the color of the leg in shadow, making it pinker and brighter as the reflected light was strengthened, and I lightened the sunlight on the hair. I also lightened the surface of the sheet and coverlet where the sunlight struck them and changed the shape of the bedding to a more interesting and complicated series of angles and edges, especially on the right. I also worked on the pillow and mattress, making their shapes, lines, and colors more interesting, and I strengthened the intersecting horizontal of the windowsill, trellis, and stone wall beyond. I got rid of the blue tones on the wall on the right and deepened the burnt umber color there. I also got rid of the unattractive purple tones of the sheets on the lower left, massing the area instead into a series of light, subtle colors and shapes.

I really enjoyed painting the pillow and coverlet, although I found the purple / blue shadow on the sheets and the cool (yet warm) tones of her legs very difficult to paint because of the very slight, almost imperceptible changes of color and tone there. Seeing the stage-by-stage photographs now, I wonder if the shadow beneath the coverlet is too cool? Yet I like its contrast against her creamy body color. I am basically happy with the painting, though. I like the way the bamboo leaves follow the line of the straight arm and complement the bent one, and the way the curve suggested by the clematis climbing plant on the balcony follows the curve of her body and yet is counteracted by the severity of the straight vertical of the string holding up the blind. But I feel that even though there is a lot going on in the upper half of the painting, the main subject is the girl. Your eyes are always drawn to the figure—by the line of the bamboo, the blind, and the trellis. Had I kept the blind as fussy and meticulous as I had first painted it, she would have become merely an incidental image in a painting of a balcony and blind.

Asleep in the Sun, 45″ x 50″ (114 x 127 cm). Collection Iain and Carrie MacArthur.

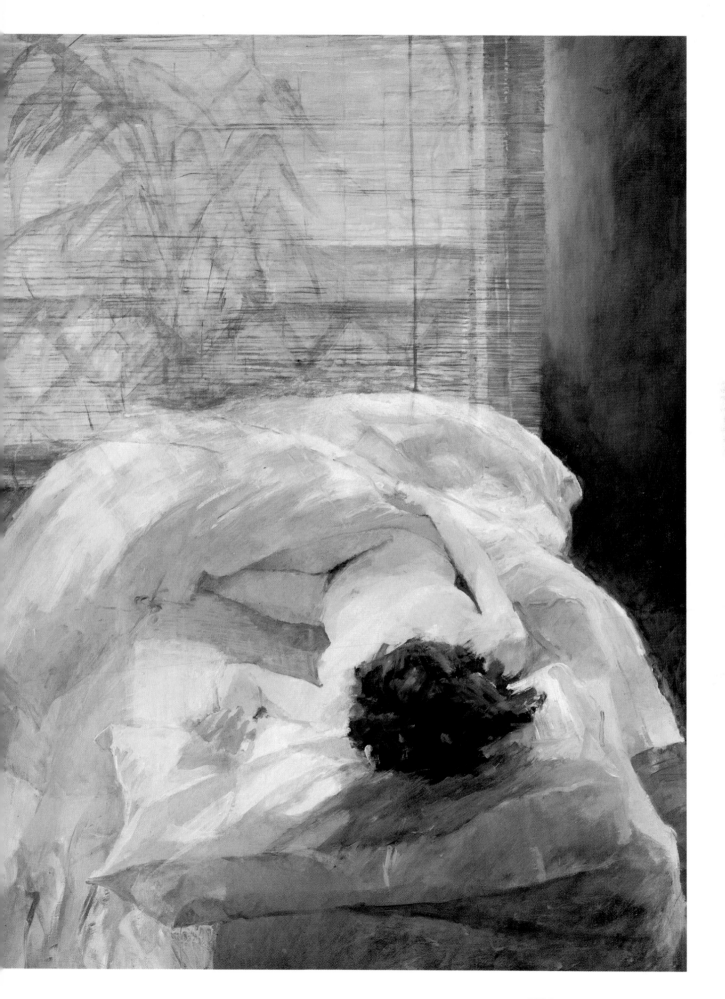

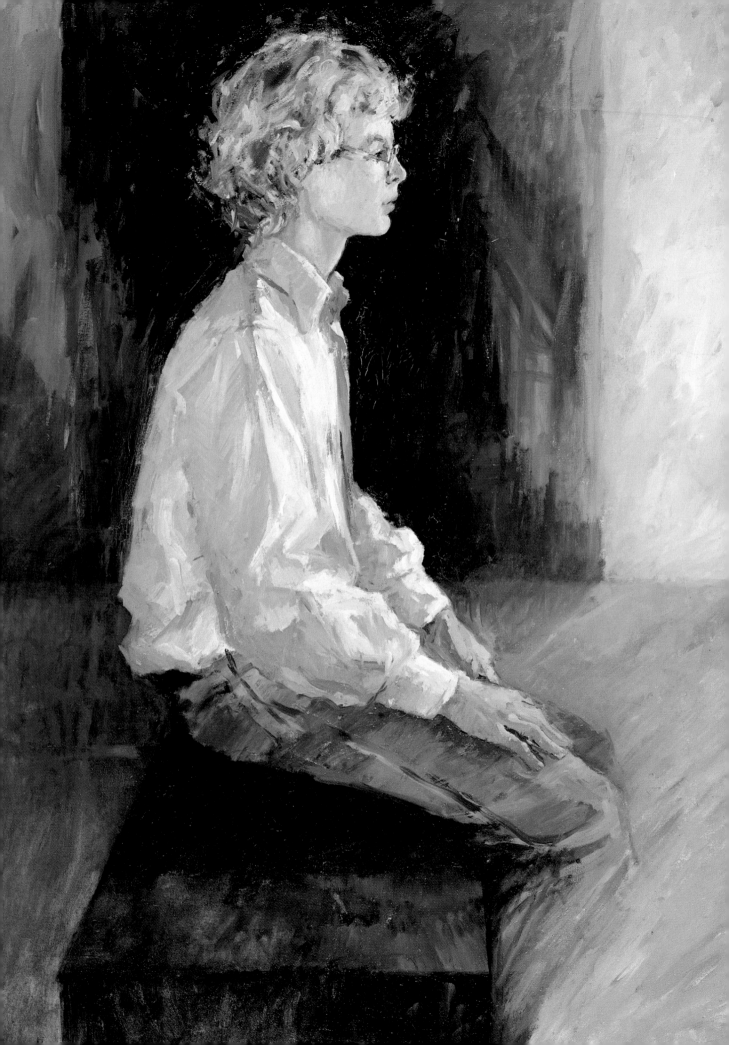

Warm and Cool Portraits

When painting portraits, there is more to consider than trying to obtain a likeness. The sitter's character and emotional makeup must be conveyed, and the setting, composition, and color scheme must be selected and arranged to describe the character and personality of the subject.

These two portraits differed from the usual commissioned portrait in that I knew the sitters, John and Kate, quite well—they were the children of a close friend. And since they felt completely comfortable with me, both sat quite naturally.

Although Kate's portrait grew casually out of studies I made of her in the studio, John's portrait was commissioned by my friend. She had wanted me to paint him before he grew up and left that delightful adolescent stage—he was already longing to grow his hair or cut it all off, throw away his glasses and get into modern moods.

I think John enjoyed the sittings. At the end of each day he would discuss the painting with me, and I appreciated his involvement and interest. When you're painting a portrait, it's very encouraging to get the feeling that you're working together with the sitter. So often a portrait become a bit of a struggle as you try not only to get a likeness, but to create a good painting as well.

John was sensitive, intelligent, and shy. To emphasize the curves of his refined, gentle features, I decided to place him in profile against a rather stark series of rectangles, including the box he was seated on. I also selected a simple color scheme of deep umbers (composed of many colors), light blue clothing, and soft pink fleshtones. The main light came from a window on the right, just outside the painting, that cast a delicate, warm light over his features and clothing. I began the background with a light underpainting of cerulean blue, over which I worked a slightly darker rectangle of colbalt blue. Then I gradually covered it with layers of viridian, French ultramarine, cadmium red, and burnt sienna, letting these colors show through here and there for interest and depth. Note the lost-and-found areas on the line between floor and wall and observe how the rapid, casual movement of the brushstrokes in the background and variations in color add interest to otherwise flat, quiet areas.

John, 40″ x 30″ (102 x 76 cm).
Collection Judy and Francis Lister.

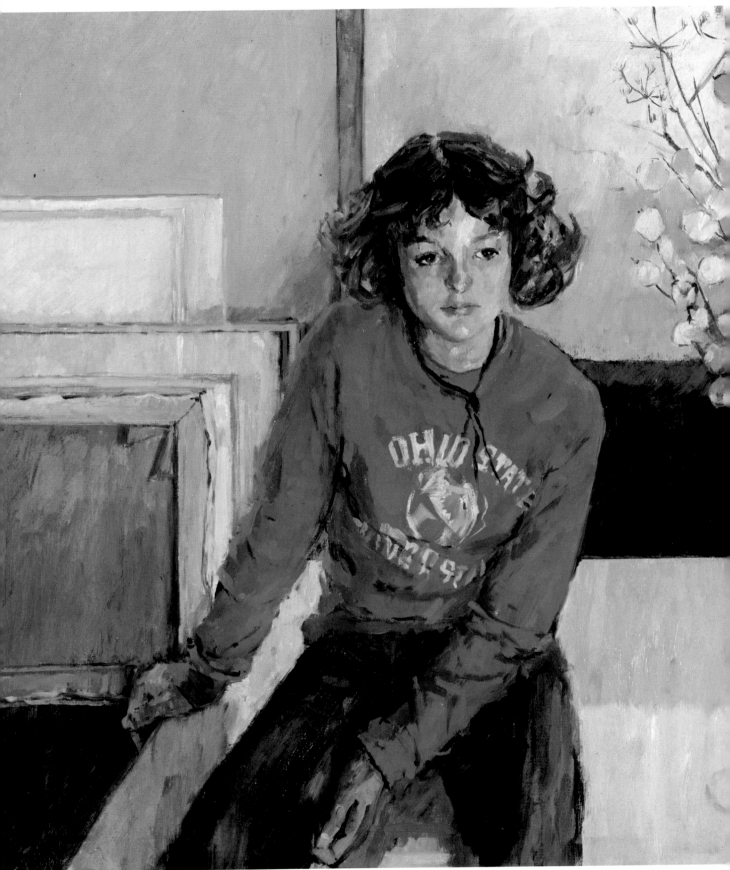

Kate, 22″ x 28″ (56 x 71 cm). Collecton Judy and Francis Lister.

I hadn't originally planned to paint Kate's portrait. She was sitting in my studio while I drew and painted her, and this painting evolved from one of those studies. Once I became interested in the study, though, I was anxious to take it further, to a complete painting.

Kate's personality was quite different from her brother's. She was confident, active, and self-assured, and the frontal pose helped convey her straightforward, frank manner. These qualities were further emphasized by her casual clothing—jeans and red sweatshirt. She fell quite naturally into this comfortable pose, and I decided to use my studio as the background—even leaving the canvases stacked in the corner—so the portrait would look natural and unposed.

There were two light sources. In the foreground, firelight shone on Kate's face and the upper part of her body, giving it a warm glow that helped convey her personal warmth. On the other hand, the blue light from the window threw its contrasting cool tones on the table and background.

I arranged the composition carefully, letting the strong squares of the window, stacked canvases, and table intersect her body in an interesting, abstract manner. I offset these angles with the curves of the earthenware jug, the circles of honesty, and the round shape of her head and emblem on her sweatshirt. Although I deliberately included the canvases—I didn't want any empty spaces in the painting at the time—I think now that the painting may suffer a little from having every area filled. I still like her warm face, though, lit by the glow of the studio fire. The winter honesty in the jug was white and, like her head, made a dark silhouette against the January sky.

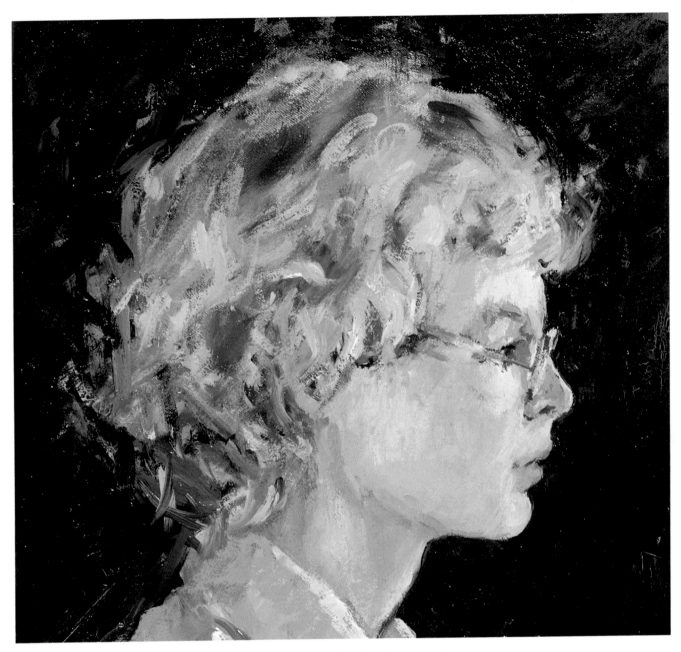

The cool tones of the shirt—cobalt and cerulean blues with burnt sienna—made the complexion appear softer and warmer, while helping to express John's gentle reserve. His flesh appeared even more delicate against the deep background. I painted the face with various mixtures of yellow ochre, cadmium red, cobalt blue, viridian, and white, with bright blushes of rose madder on the cheeks and hands and dark accents of burnt sienna and blue on the nose, ear, and eye. His blonde hair was a combination of yellow ochre, terre verte, and white, with cobalt blue added in the darker areas.

It's hard to describe character through a profile—the eye is constantly led to the edges of the form and the head tends to look flat. To counteract this, I painted bright spots of color near the cheekbones and defined the features, and the forms and planes of the head, more carefully than usual, to emphasize the three-dimensional quality of the head and describe John's expression. Note how the light left distinct (though subtle) edges at the junction of the front and side planes of the head. The neck is yellower than the face, with viridian and yellow ochre undertones, and there are some cobalt blue reflections from his shirt on the jaw.

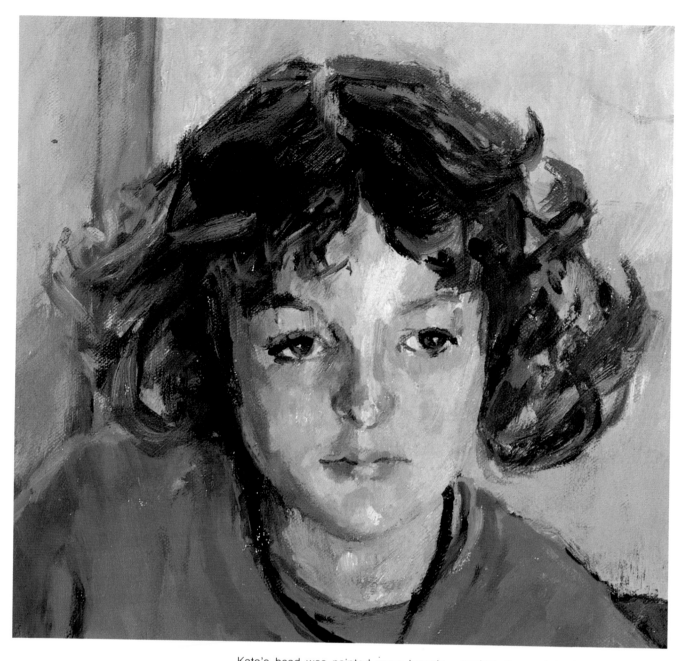

Kate's head was painted more loosely than John's in keeping with her extroverted, exuberant vitality. Her flesh was painted with mixtures of yellow ochre, burnt sienna, cadmium red, rose madder, and white, cooled and softened with touches of cobalt blue, French ultramarine, and viridian. The cool light of the window (painted with tones of cerulean blue, French ultramarine, viridian, and white) intensified the warm colors on her face. Her warm brown hair (burnt sienna, yellow ochre, and French ultramarine) framed her face and created a barrier against the cool background daylight. The glow from the fire and the intense red color of her sweatshirt made her face appear even warmer. This strong color gave me an excuse to strengthen the tones on her face, which I had wanted to do anyway. Note the way I brought the cool daylight into her parted hair, linking the two areas. I painted the base of her hair a transparent burnt sienna and French ultramarine, adding opaque yellow ochre and white tones to it where it bounces upward and catches the light.

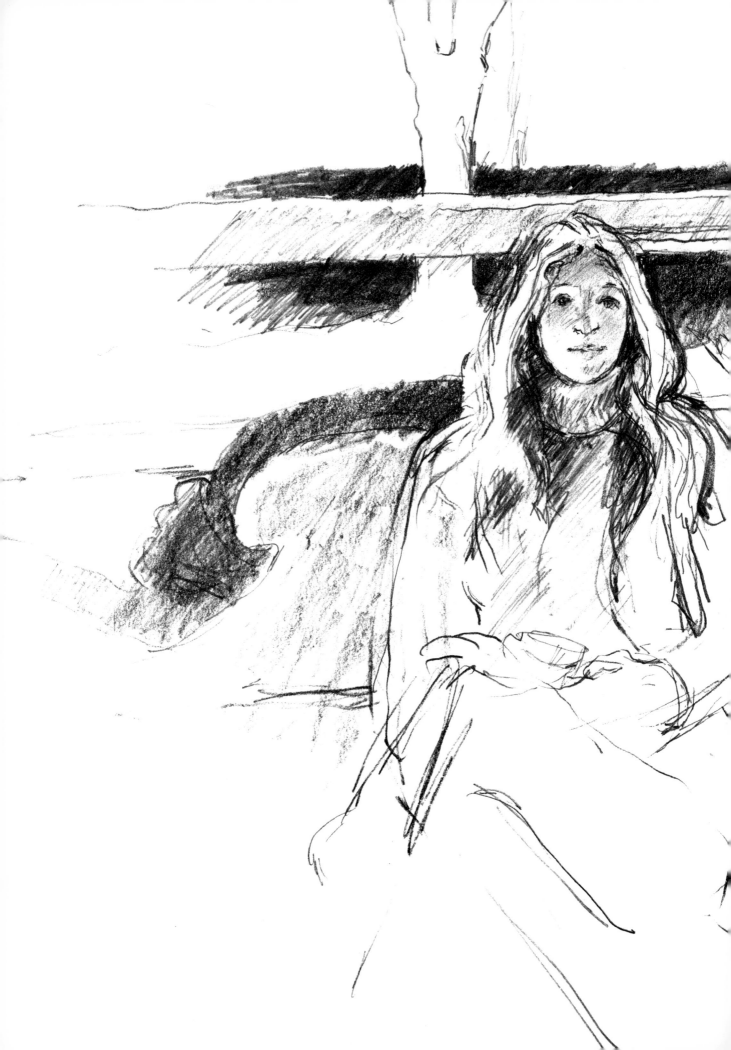

Same Subject, Two Interpretations

In the beginning, when I meet a sitter for the first time, I like to do what I call a "get-to-know-you" drawing. I use it to work out ideas for a portrait, to discover which poses come most naturally to the sitter, and to put the sitter and myself at ease.

It's hard to say how I will perceive and paint a sitter. Some sitters are extroverted and talk as I work, while others are quiet, content to drift in and out of their own world. Annabel was probably ill at ease and nervous at first because she sat rather straight and still as I drew her, and I had the feeling that she was longing to drink the coffee she was holding but was afraid to move. But I did not say to myself in looking at her, "Annabel is shy and nervous, so I will paint her that way, in shades of blue, and so forth." It wasn't as cut and dried as this—and it's always much easier to analyze a sitter in retrospect. However, somewhere in the back of my mind, I suppose, the unconscious awareness of qualities I sense in a subject sets the nature or temperature of the painting from the start. Also, as I get to know a sitter better, my preliminary impression changes and one portrait often leads to others, as it has here. (I would love to paint John again, for example, when his character becomes more assertive.)

I liked the composition of this sketch of Annabel—her face dark against the window, surrounded by her fair hair. But while it worked well in black and white, I felt that it wouldn't translate well into color. The value contrasts and patterns of light and dark in the background were just too strong and compelling, and they distracted from the subtle tones on her face in shadow, making it only of secondary interest. Also, as I later came to know Annabel, I realized that this drawing did not portray her true character. She was too stiff and posed here, not at all relaxed.

Since neither of these paintings was commissioned, I had a completely free hand. I first painted Annabel while she was sitting in a corner of my studio, lit by a cold north light that seemed to suit her dreamy personality. At first I painted her in profile, looking out the window, gazing into the distance, with no dramatic changes of light and dark, only gentle shifts of tone caused by the bamboo blinds. But it just didn't work. She looked awkward resting on the window ledge, which was just a little too high for comfort. Although I obstinately painted—and continued to repaint—her this way, I was dissatisfied, and after each sitting, I ended the session by scraping down the day's work. After about four or five tries, I sadly decided the painting was a complete failure.

I did not know Annabel well when she first sat for me, but as I painted her on subsequent sittings, I was struck by the changes in her facial expressions. At some times she would just look pretty, while other times her face would take on a "tremulous sensitivity"—I don't know how else to describe this crumbling confidence of her features. One minute, a totally assured person, at another, shy and lacking in self-confidence—and it was this latter side that I wanted to portray. One afternoon, quite forgetting her profile pose, she sat like this. I saw immediately that this was much more in tune with what I wanted, so with the previous head as a base, I worked quickly and painted her with more assurance and freshness in this new position.

LIGHT SOURCES

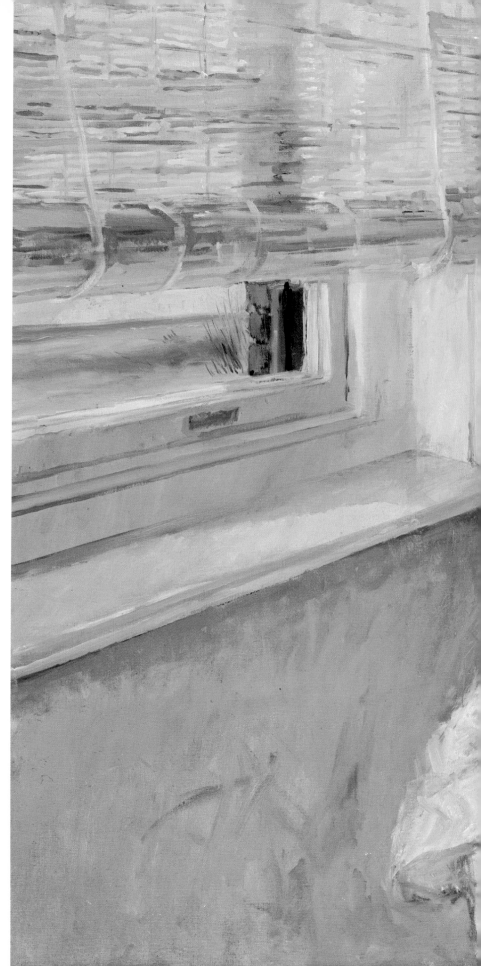

Annabel Khanna, First Version, 30″ x 40″ (76 x 102 cm). Artist's Collection.

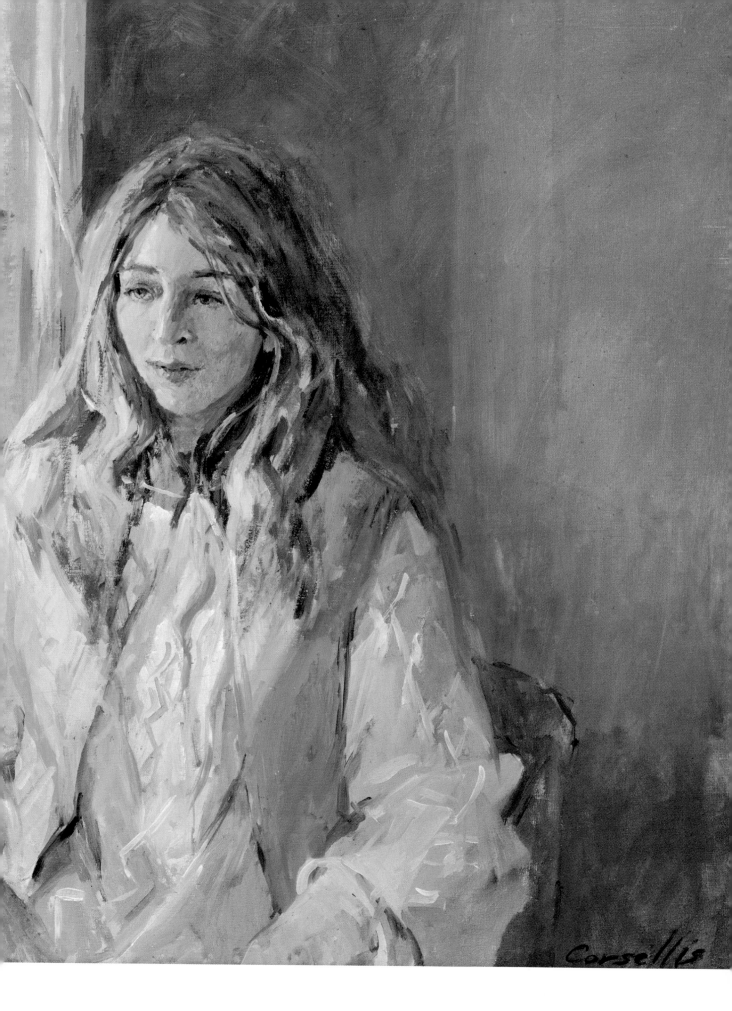

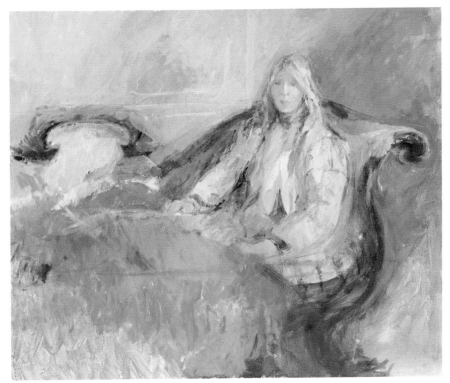

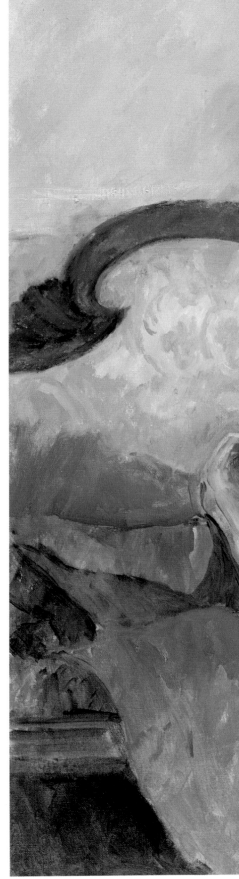

Stage 1

Working over a warm yellow under-painting, I gradually built up the basic composition and loosely blocked in the major shapes and masses. I toned the background wall behind the couch with broad strokes of cerulean blue with lots of white, lightly suggesting a window behind the couch. (I decided to underplay this window completely so I could strengthen the light on her face, thus avoiding the problems created by the bright backlight of the earlier sketch.) The dark burnt sienna curves of the sofa stabilized her form and added interest to the composition. The yellow tones of her hair were echoed in the shadowed wall on the right, on the left-hand side of the couch, and in the window area. I also blocked in her pink dress and the blue blanket, loosely noting the position of placing her crossed legs and the hem of her dress. The important thing at this early stage was to establish the general color areas and balance them first, before adding specific details.

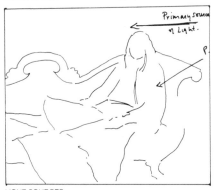

LIGHT SOURCES

Finished Painting

Although I was pleased with the first painting and in many ways like it better than the second, I think it had not shown Annabel's fine features to their best advantage, so I decided to try again. Her quiet patience and the fact that there was no time limit on this portrait gave me the marvelous feeling of working without intense pressure. Yet when I look at the painting now, I can see from the numerous overpaintings and many thin glazes and alterations, that I was concentrating more than I realized. But I think that the quiet, relaxed nature of these sittings produced a much freer painting than previous sittings.

In posing Annabel, I was unashamedly influenced by having seen Marie Laurencin's painting *Girl on a Sofa* in Christie's catalog. I liked the way the light shining from the right-hand side cast her shadow on the wall behind the sofa. I wanted the values surrounding Annabel to be similar—the sofa, blue rug, her legs, and the arc of the rug again—so that they would appear to encircle her, spotlighting the upper part of her body, which was lighter. The dark wood of the sofa also had the same rhythmical, encircling effect.

I had trouble coming to a final decision on the shape of her knees and the rug. I tried painting her with her knees bent, but it looked too awkward. Yet the painting did need a diagonal—so I finally decided to place a folded newspaper on her lap to counteract and balance the curves and angles, and redirect the eye up her arms to her face.

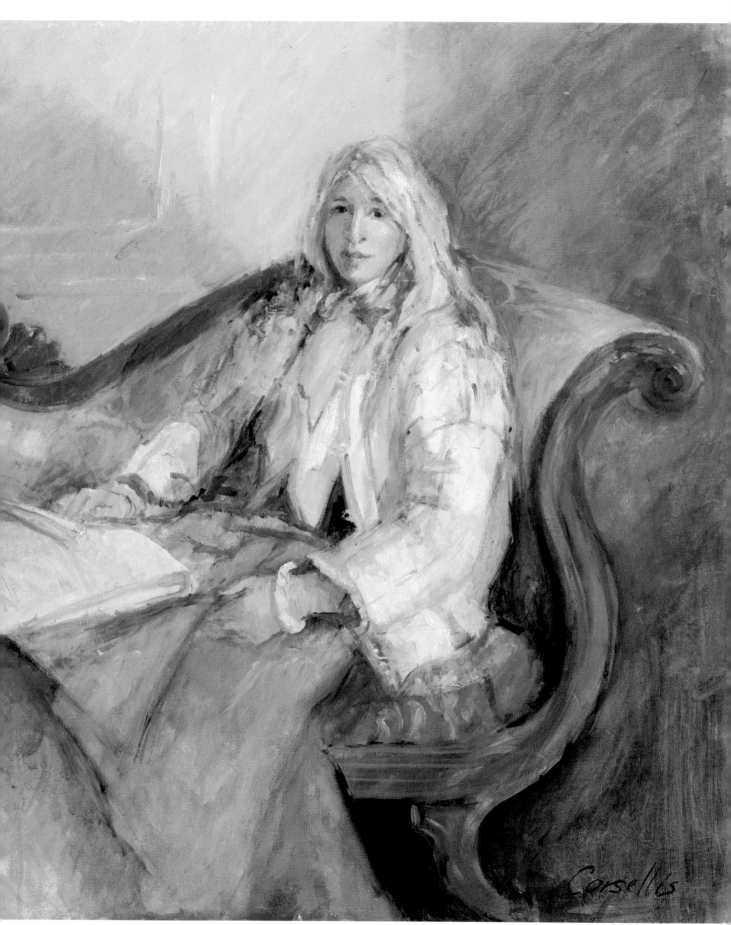

Annabel Khanna, Second Version, 25″ x 30″ (64 x 76 cm).

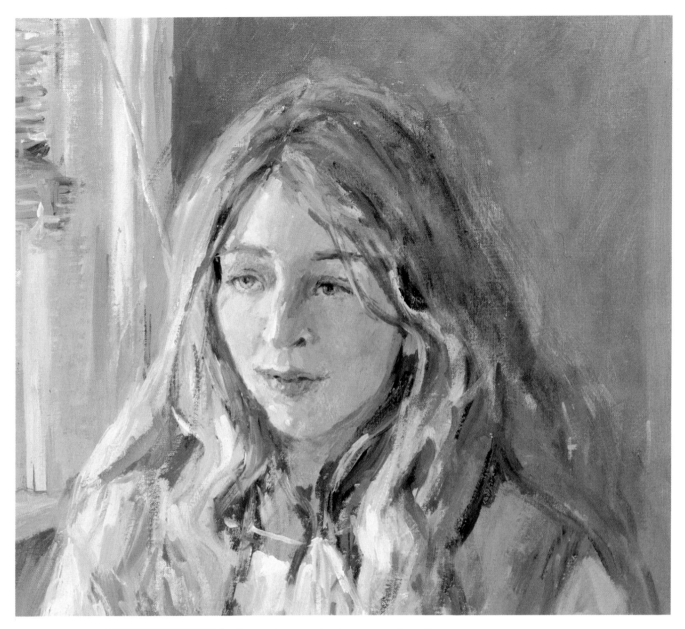

It is not unusual, when I am struggling with a portrait, to find that even the slightest change of position can make my eyes fresh again. Painting over a previous (dry) painting also helps—the basic color is there and a few deft touches often make all the difference. Despite the many scrapings, the painting had a nice fresh quality, and the old paint proved to be a receptive surface to work on.

This time I painted her turning toward me, and with luck—and I think because of the quality of the underpainting—the portrait was completed in two sittings. Although I find it less ''pretty'' than the second portrait, I much prefer it not only as a painting but because it reveals more of her sensitive nature.

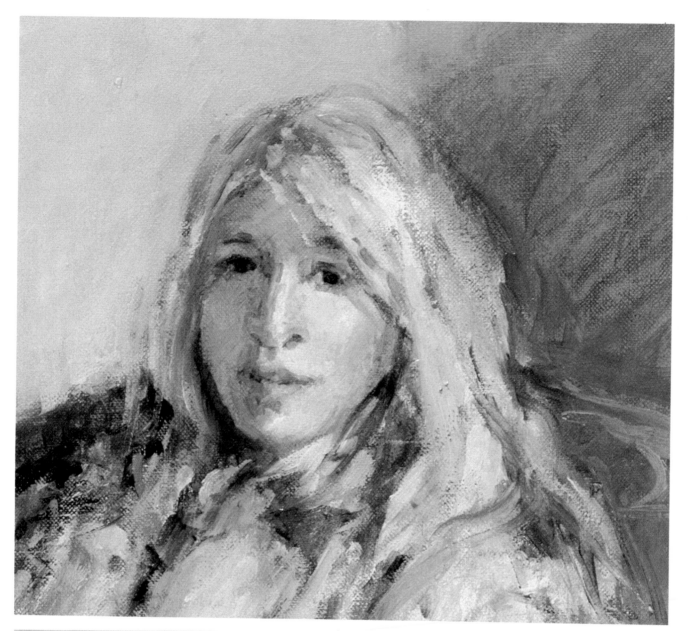

The second painting involved a completely different state of mind and mood. First of all, the lighting was different. Unlike the first version, which was done under a cold north light, the second painting was done in a sitting room that faced south, where the light was warm and sunny. Secondly, Annabel's mood had also changed, particularly because by this time she was expecting her first baby, and so she was relaxed, happy, and self-assured. Also, since the character and mood of a sitter is subconsciously reflected in a painting, the nature of this painting as a whole was calm and confident. Thirdly, the quality of the brush-strokes and color, which also describe the mood of a painting, was different. The first painting was done quickly and the brushstrokes there are vigorous and rapid. But this painting was done more slowly, with a gradual buildup through glazing and scumbling, so the final effect is more gentle and subtle. Finally, the lighting was changed—it is warmer here—and since she is further from the window, the edges are softer, the colors more muted, and the contrasts in value less great.

Creating a Relationship Between Two Figures

I started this painting some years ago as an informal portrait of two musician friends. Since they used to spend much time working together, I had ample opportunity to make drawings and separate studies on leftover pieces of canvas taped on to Masonite (hardboard). I much prefer this support to canvas paper, which has a slick, polished surface that seems to repel the paint, causing it to slip all over the paper in an unattractive way.

Charcoal Sketch

I once watched a bass player in an orchestra. The others in his section seemed to stand apart from their instruments, but he stood close to his bass and almost appeared to cradle it in his arms, as if it were part of him. This fascinated me and I tried to capture his emotions in this charcoal sketch. I wanted to convey this intimate relationship in the painting, but I soon discovered that the composition of two musicians and a double bass presented many problems. One problem was caused by its size. The bass was so large and dominant that it appeared to conflict in shape and importance with the figure of the girl on the stool. So although I was excited about the idea for this painting, I had to resolve this awkward compositional problem first before I could begin the painting. I decided to try and work out the solution in an oil study.

Oil Study

I worked on a piece of leftover canvas taped to Masonite, using soft nylon brushes and a palette of white, burnt sienna, cerulean blue, French ultramarine, cobalt blue, and terre verte. As I studied the composition, I used color to emphasize the mood, and so I deliberately exaggerated the cool greens that silhouetted her figure.

I tried to capture the relationship between the two figures. The bass player stood quietly by his instrument, his face featureless against the window. The girl sat apart from him, outlined against the glass doors, her figure echoing the shape of the bass. The study lacked ''breathing space'' and a sense of concentration, so I resolved to include more of the room, with its unusual inward-opening windows in my painting. I also decided to exaggerate the sensation of light flooding in from the window and doorway.

The more I examined the shapes in the painting, the more awkward they appeared. The bass dominated the room, and to counteract this I darkened the background and moved the bass player to one side so the instrument appeared against the dark column between the windows. I also felt that the value contrast between the girl and the doorway behind her was too strong and that I had overstated her shape in relation to the similar curves of the bass.

I finally realized that the problem lay in the instrument itself, and decided to exchange the bass for a cello. At once, the situation was resolved. The cello was far less overwhelming and created a more effective, ''circular'' relationship between the cellist, the cello, and the girl. But as I started the larger canvas, I discovered that there were still more problems to overcome.

Stage 1

I deliberately chose a large canvas for this interior because the rehearsal room was large and light: the sun streamed in, leaving the empty room glowing with light. I began by covering the canvas with a dark neutral tone of cerulean blue and burnt sienna with some terre verte, using a large brush, switching to a smaller sable brush to define the window, blind, and floorboards. I worked slowly as I developed the painting.

I moved the figures further apart, increasing the spacious feeling of the room. But I was bothered by the difference between the dark tones on the girl's face and body in relation to the lighter tones of the cellist. It made them seem too separate, too distant from one another. (However, I liked the fact that her braids repeated the shape of the tree trunks outside the window, linking the two areas.)

Before I could continue to work, I had to solve this second problem. So I made another small study, this time in pencil, white chalk, and watercolor washes to work out these value problems. Meanwhile, work on the painting was soon complicated by the breakup of the marriage of these two musician friends. With that, I lost all enthusiasm for the painting and it remained in this unfinished state for a year.

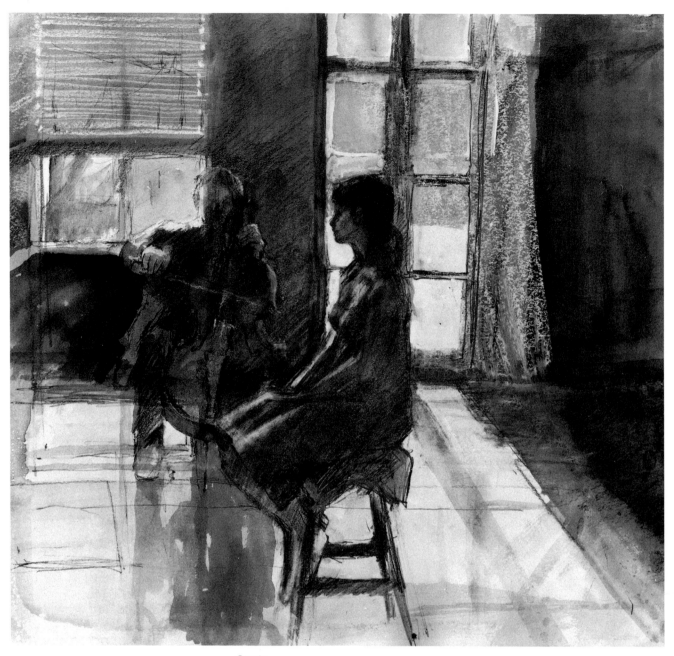

Study

One of the aspects of the painting that bothered me was the large channel of light between the girl and the cello. It ran from the top to almost the base of the painting and appeared to divide it into two halves vertically. I tried to decrease its size on top by moving the dark column of the wall closer to the girl. I also closed the door and used the bars on it to break up the light into smaller units. Then I added a lace curtain to the door for texture and to move the eye into the room with its long, sweeping lines, but found it too distracting and later modified it in the painting. I also broke up the light on the floor by increasing the size of the cellist's shadow

and joining it to the shadow of the wall, and I used its dark vertical shape to link the two dark shapes of the figures.

I didn't like the way the cellist's arm had pointed away from the girl as he faced the music stand, so I curved his arm toward the girl, letting the hand and bow point to her, thus creating a circular effect. To emphasize this curved line, I let the sunlight fall on the upper part of his arm, like a light stripe. I also removed his music stand and had the musician face the woman, with his face and body in darkness. But I changed my mind about introducing that aspect of the pose into the final painting.

One day I came across some of the studies I had made for this painting earlier and, still intrigued by the original idea, I once again began to work on it. Once it was on the easel, I became quite excited, for I could see many things that needed to be done.

I began by altering the perspective of the wooden floor boards so the floor no longer seemed to fall out of the base of the painting. I strengthened the lines of the music stands, window, and many other small details, defining their shapes and colors so that each element served a purpose in the painting as a whole. I also corrected some of the tonal relationships. For example, with a rag, I rubbed burnt sienna and turpentine into the wall on the left to warm up the tones there and match them in feeling to the tones on the opposite wall.

I broke up the broad space between the girl and cello by putting some hard and soft edges there of white, viridian, cerulean blue, and burnt sienna. I added a soft tone of burnt sienna to the doorway and overpainted it with light crossbars and a gentle, transparent curtain blowing in the breeze. The lines of the curtain lead the eye to the girl's arms, then up to the music stand through the counteracting diagonal of the legs. (The original idea, of moving the column of the wall closer to her head, was not a good one because it compressed the space in front of her face too much. But the study did give me the idea of using the bars and the curtain to break up the space without completely enclosing it.) I also used the long, dark shadow (of burnt sienna and terre verte) in front of and below the cellist to divide the two light areas and lead the eye to the center of the painting. (I had used a similar solution in *Rehearsal Room* to link the standing dancer and the stove with the dark column of the far wall.)

Now that the painting was finished, I could see that the tones were correctly balanced, the lines flowed smoothly into one another and around the painting, and the painting worked smoothly as a whole, with no single element becoming too distracting at the expense of another.

Adagio, 50″ x 60″ (127 x 152 cm). Collection Robert Nelson.

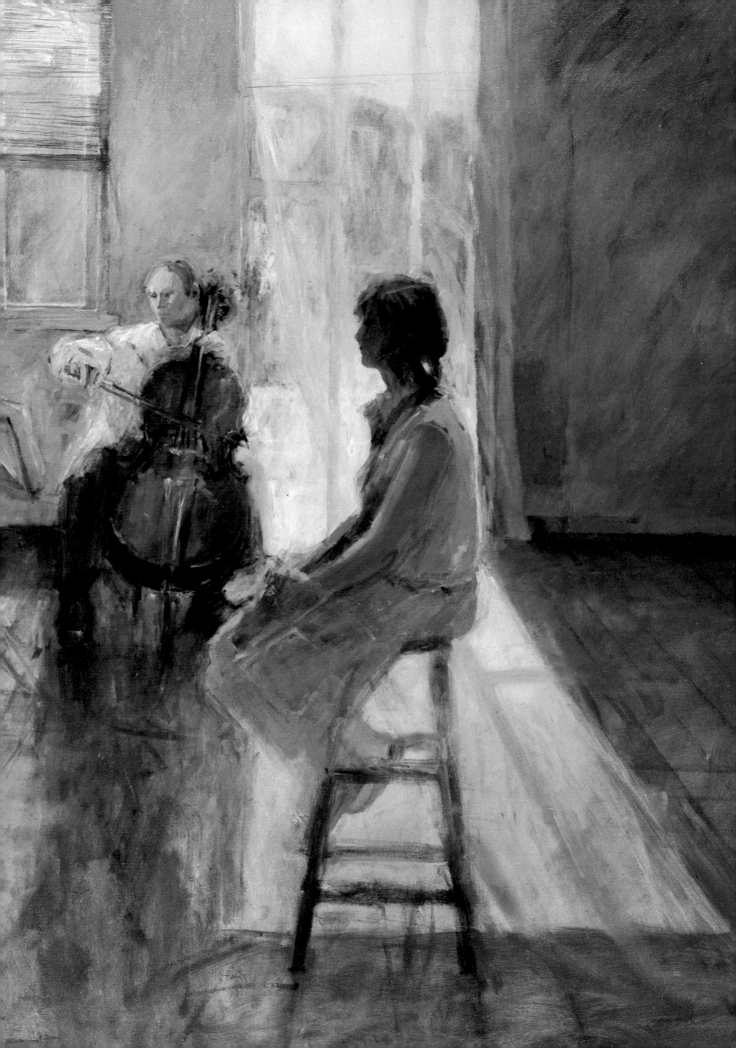

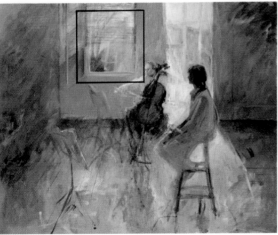

Stage 1
At first I made the color temperature outside this window cool and omitted the dividing strut down the center of the frame. Although it worked in that early stage, it lacked real interest and appeared "tame," especially once I started working on other elements of the painting and developing them.

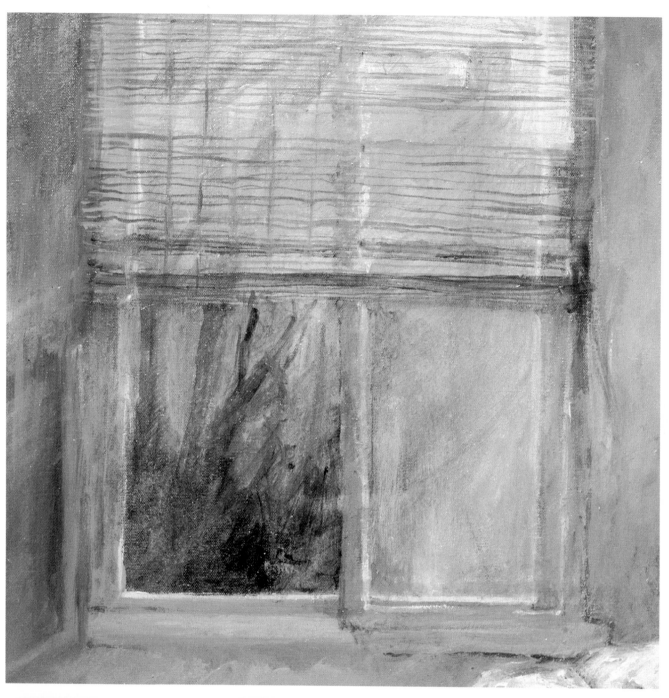

Stage 2

By adding a central strut and applying a warm glaze to the window, I created much more impact. I also redrew the blind, adding more slats and making it yellower in tone as the sun shone through it, with some flecks of white spotted in places to express the intensity of the light outside. This entire window area strengthened the atmosphere in the rest of the painting, giving it a feeling of shaded sunlight on a lovely afternoon.

In retrospect, I think that I had spent so much time trying to resolve the composition that I ran out of enthusiasm for painting the tones and color. But the lapse of a year restored my confidence and completing the painting was much easier than I thought.

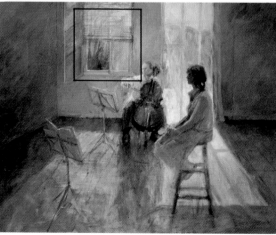

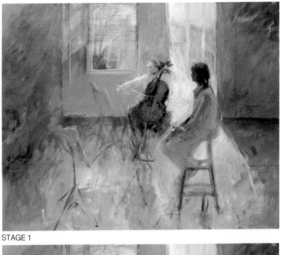

STAGE 1

FINISHED PAINTING

Even though I had solved the problem of the sizes of the musicians and the cello in the study, the girl still appeared detached from the rehearsal, both emotionally and physically. The cellist and his instrument faced the music stand and seemed to ignore her. The arm holding the bow pointed directly at the music and the other hand was high on the neck of the cello, continuing the diagonal line to the left. Despite the slight dip in the music sheets, which briefly directed attention to the girl, she still appeared isolated.

To correct this, at first (in Stage 1) I had the girl slump in the stool slightly, directing the upper part of her body toward the cellist in a gentle half-circle. But that movement linked her dark figure with the wall on the right, making *them* a unit, instead of uniting her with the cellist on the left. However, I reflected tones from the rest of the room—the viridian of the wall on the right—into her shadowed clothing to relate her to the rest of the room and prevent her shadow from being too blue.

To link the girl with the cellist, I moved her away from the wall in the finished painting by altering her posture, drawing a thin fillet of light down from the doorway that widened the area between her back and the wall. This tiny strip of light changed the balance of light and dark in the area and balanced the distracting influence of her silhouette on the left.

Then to direct attention to her, I changed the position of the cello, half turning it toward her in token acknowledgment of her presence. I also altered the angle of the cellist's right arm so he appeared to be halfway through a stroke across the strings rather than posed statically with the tip of the bow on the cello. His left hand was just above the body of the instrument with his elbow lowered behind it. These changes altered the focal point of the painting and, with the parallel lines on top of the music and bow, pulled the central group into a unit that directed strong diagonal lines toward the girl. Now that the cello faced the front of the painting, it seemed much easier to "listen in" to the musicians than it did before, when they appeared at rehearsal as a tight, introverted group.

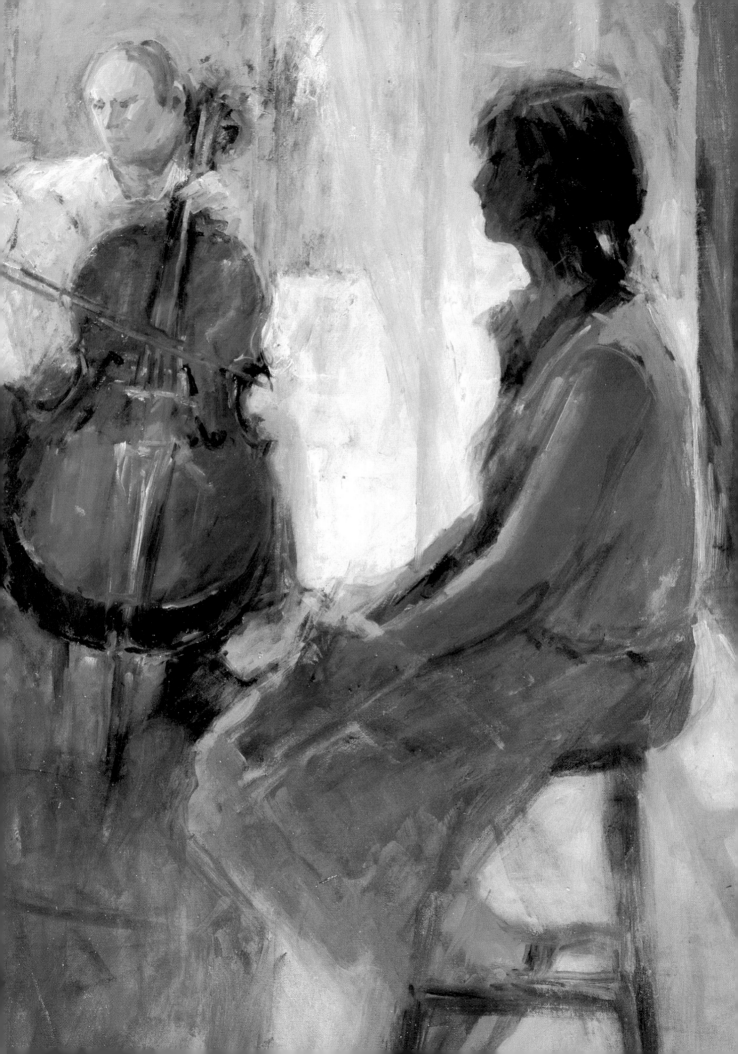

Index

Edited by Bonnie Silverstein
Designed by Bob Fillie
Graphic production by Ellen Greene
Set in 9-point Vega Light